POSTCARD HISTORY SERIES

Weymouth

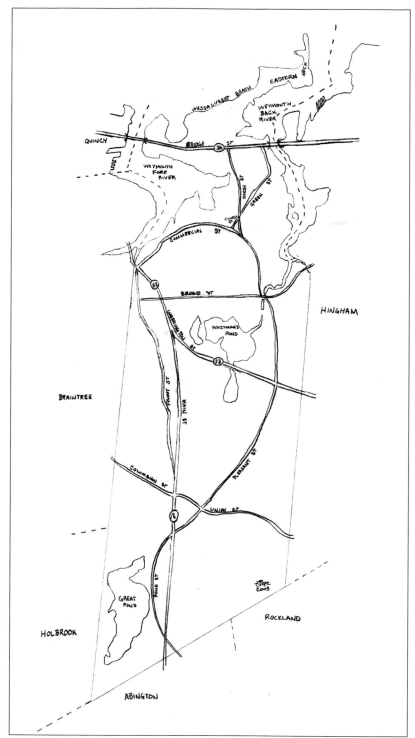

This map shows most of the streets and highways of Weymouth that are pictured on the postcards and mentioned in the text of this book. Drawn by Franklin Pepe, the authors' son, the map is included to help readers better visualize the locations of the sites.

POSTCARD HISTORY SERIES

Weymouth

William J. and Elaine A. Pepe

ARCADIA
PUBLISHING

Published by Arcadia Publishing
Charleston SC, Chicago IL, Portsmouth NH, San Francisco CA

Printed in the United States of America

Library of Congress Catalog Card Number: 2003114520

For all general information contact Arcadia Publishing at:
Telephone 843-853-2070
Fax 843-853-0044
E-mail sales@arcadiapublishing.com
For customer service and orders:
Toll-Free 1-888-313-2665

Visit us on the Internet at www.arcadiapublishing.com

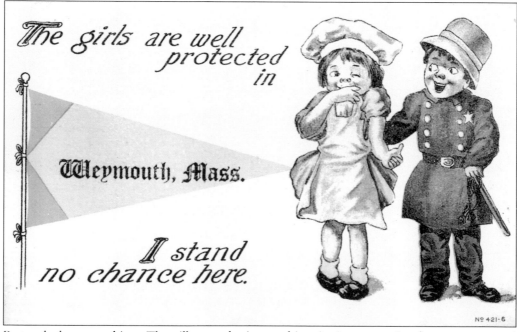

Postcards do many things. They illustrate businesses, historic sites, recreational areas, scenes, and so forth. They carry an unlimited variety of messages, including greetings, medical reminders, advertisements, government notices, and humor. This card, which illustrates the humor of the period, is postmarked 1915.

CONTENTS

Acknowledgments 6

Introduction 7

1. Weymouth Landing 9

2. Weymouth Heights 25

3. North Weymouth 33

4. East Weymouth 57

5. South Weymouth 91

6. Potpourri 119

ACKNOWLEDGMENTS

Numerous people and organizations contributed to the preparation of this book. Listed in alphabetical order, the individuals are Harry Bearce, Jennifer Durgin, Charles Cowing, Elizabeth Emde, Joseph Hayes, Elizabeth Hollis, Don Junkins, Carmella LoPresti, Mary Lyons, Robert Lyons, Donald Mathewson, Wilfred Mathewson, Robert Munroe, Franklin Pepe, Salvatore Pepe, and Candace Wright. Contributing organizations are Weymouth United Methodist Church, the South Shore Historical Society, the Thomas Crane Library of Quincy, the Tufts Library of Weymouth, and the Weymouth Department of Public Works. We wholeheartedly thank all of them for their valuable contributions.

If we have inadvertently forgotten to mention others who assisted, we thank them also and apologize for not including their names.

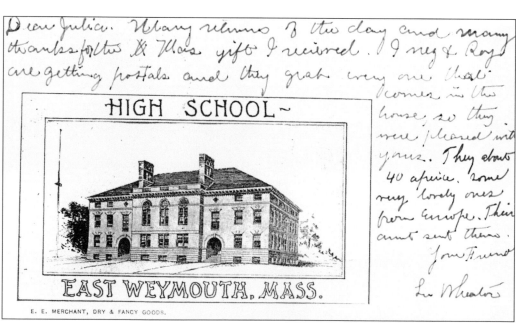

This card indicates that postcard collectors have been around a long time. It reads in part, "Dear Julia, . . . Inez and Roy are getting postals and they grab every one that comes in the house, so they were pleased with yours. They [have] about 40 apiece, some very lovely ones from Europe. Their aunt sent them. Your friend, L. Wheator." The card is postmarked January 6, 1905.

INTRODUCTION

Weymouth has been settled since 1622. This book explores only a small portion of the town's nearly 400 years of history, the portion that is captured on postcards.

On December 24, 1901, Congress authorized the use of the words "Post Card" on privately produced mailing cards. Almost immediately, professional and amateur photographers published postcards of significant (and often insignificant) places and events that constitute the daily fabric of American life. Over the years, postcards passed through various styles, or eras. Humorous postcards were, and still are, popular. They, too, reflect the value systems of 20th-century America.

With television showing us images of every corner of the world, with the ease of telephone communications and the advent of e-mail, the popularity of picture postcards has dramatically declined. But the working postcard is thriving.

The postcard is not in a sealed envelope, and its message is therefore more likely to be read. How often do you receive a political advertisement by postcard? A reminder of your medical appointment? An advertisement from a local merchant? A reminder for meetings? A reminder from a local charitable organization? Put these together and you can get a picture of your life and times.

In this book, we have assembled Weymouth postcards to give you a partial picture of 20th-century Weymouth. Our emphasis is on the first half of the 20th century and the picture postcard. Now to our postcard tour of Weymouth.

HIGH SCHOOL, EAST WEYMOUTH, MASS.

The *c.* 1900 card shown is a precursor to the postcard. It was used as one would use stationery, enclosed in an envelope and mailed. You paid the full letter rate. This particular card carried a lengthy message to Doris's aunt. The illustration on the card is Weymouth High School with no wings. The high school, of obvious pride to the community, is illustrated just as it was constructed in 1898.

One

WEYMOUTH LANDING

COMMERCIAL STREET, WEYMOUTH, MASSACHUSETTS 3862

Weymouth Landing is a community that grew on both sides of Smelt Brook, a stream that separates parts of the towns of Weymouth and Braintree. This late-1940s view of Weymouth Landing shows the unity of the two towns. The pedestrians in the center are in Weymouth. The police traffic control box, just beyond them, is in Braintree. (The box is more clearly seen on the bottom of page 12.) Smelt Brook, which separates the two towns at this location, is channeled under the road. The card is postmarked 1951.

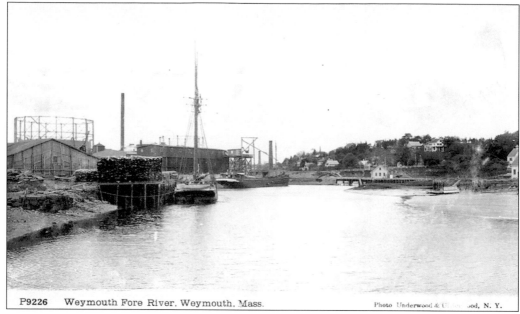

P9226 Weymouth Fore River, Weymouth, Mass. Photo Underwood & Underwood, N. Y.

Weymouth Landing received its name from the maritime activity (boat landings) that flourished there before turnpikes, bridges, and railroads created alternate means of transporting goods and people. This early-20th-century industrial view illustrates maritime activity on both the Weymouth and Braintree shores of Weymouth Landing. The card is from *c.* 1920.

BOAT LANDING WEYMOUTH, MASS.

Another view of maritime activity on the Weymouth Fore River shows a mix of recreational boating and commercial shipping. Today, you can still find both recreational and commercial maritime activity on both shores of the Weymouth Fore River system. The postcard is postmarked 1923.

10

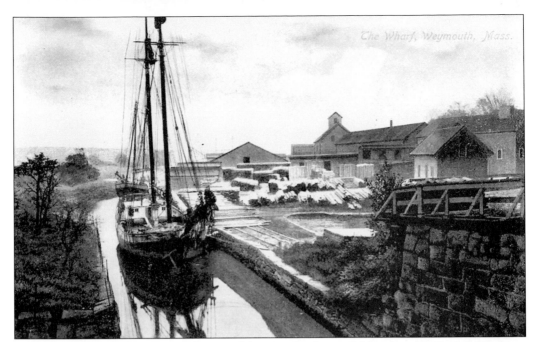

Here we have a close look at a schooner delivering lumber to Rhines Lumber Yard. Rhines was located between the river and Commercial Street, the old stagecoach route. In the 17th and 18th centuries, several wharves and piers were located at the site of Rhines Lumber. Rhines helped meet Weymouth's lumber needs for about a century, from *c.* 1870 to *c.* 1970.

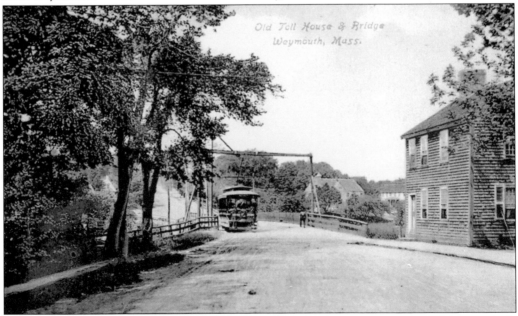

Around 1805, the Braintree and Weymouth Turnpike Corporation built a toll road popularly nicknamed the Queen Anne Turnpike. The road is now a part of Route 53. Here we see a trolley on the Quincy Avenue portion of that road crossing the bridge at the headwaters of the Weymouth Fore River. The building on the right is the old tollhouse. Tolls were not collected after 1863.

11

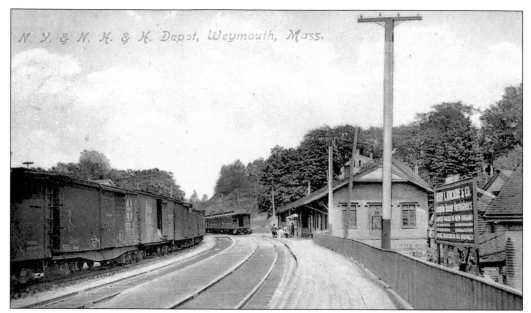

Barely over the town line into Weymouth stood the Weymouth Landing depot of the New York, New Haven and Hartford Railroad. The trains have been inactive since the 1950s, but the state is planning to revive service on this line. The billboard on the right reads, "Henry L. Kincaide & Co., Complete House Furnishers." The sign goes on to tell the merits of the firm and its Quincy address.

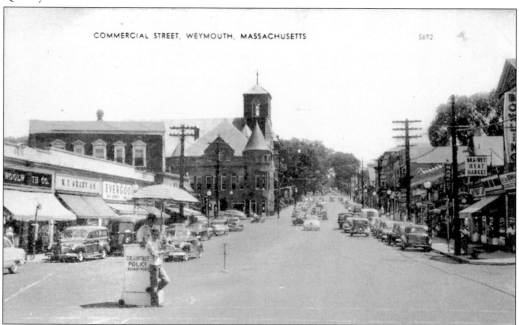

COMMERCIAL STREET, WEYMOUTH, MASSACHUSETTS

Another late-1940s view of Weymouth Landing shows the unity of the two towns. This time we are looking from Braintree into Weymouth. In Weymouth, the buildings on the left have a Commercial Street address. Those on the right have a Washington Street address. Smelt Brook, the border of the two towns, is channeled almost directly beneath the Braintree police box. There are no traffic lights.

Because members of this two-town community wished to worship together, they organized a common religious society that evolved into the Union Congregational Church of Weymouth and Braintree. They erected this magnificent church in Braintree, on the new Queen Anne Turnpike, at the headwaters of the Fore River. The church became functional in 1814. The postcard dates from c. 1907.

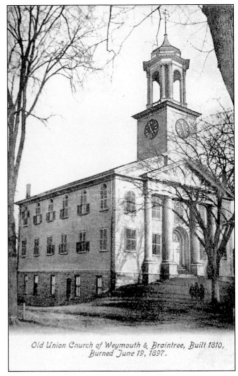

Old Union Church of Weymouth & Braintree, Built 1810, Burned June 19, 1897.

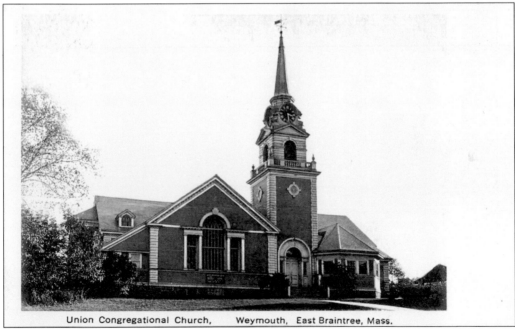

Union Congregational Church, Weymouth, East Braintree, Mass.

The railroad came to town c. 1845 and passed close to the church. In 1897, a piece of coal from a passing train ignited the original Union Congregational Church of Braintree and Weymouth, and the building was destroyed. The congregation built a new house of worship a short distance away. It still stands and, like its predecessor, carries the name of and serves the two towns. This 1907–1914 card is postmarked 1947.

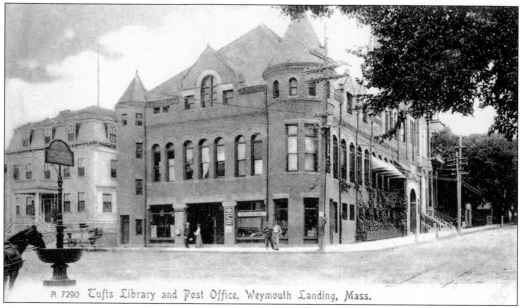

A 7290 *Tufts Library and Post Office, Weymouth Landing, Mass.*

The main branch of the Tufts Library (1892–1965) dominates Washington Square. The former Wales Hotel, a stagecoach stop, is to the library's left. Just picture a team of horses racing down the hill from Braintree, swinging a hard left on Commercial Street and pulling up in front of the Wales Hotel. Today the fully renovated Wales Hotel is the rectory of Sacred Heart Church.

This card presents us with another view of the main branch of the Tufts Library. In 1879, Quincy Tufts and his sister Susan willed the town sufficient funds for the purpose of starting a library system for the town's citizens. The card is from the 1901–1907 era, with plentiful space on the front for a personal message.

14

Here we have a majestic view of the Sacred Heart Church in Washington Square. In 1869, St. Francis Xavier Church, the only Catholic church then in the town, was destroyed by fire. Rather than rebuild as a large church, the decision was made to build several churches around town. Sacred Heart is one of the churches built at that time. The postcard is from the full-photo era (1907 to 1920).

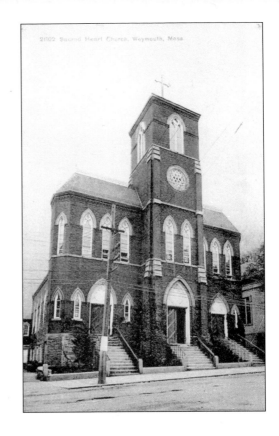

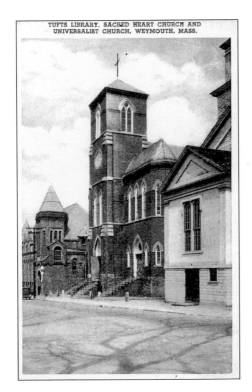

This postcard from the white-border era (1915 to 1930) shows us the proximity of three landmark buildings. Notice how the 1892 library (left), the *c.* 1872 Sacred Heart Church (center), and the *c.* 1839 First Universalist Church (right) are shoulder to shoulder and virtually on the sidewalk for the convenience of the pedestrian. Suburban sprawl was impractical at the time of their construction.

15

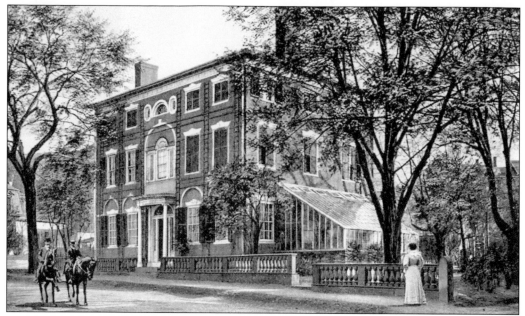

Shown above is the Francis Cowing house (built in 1803), a private residence noted for its beauty. In 1825, the first meeting of Orphan's Hope Masonic Lodge was held here. Notice the horsemen, the pedestrian, and the nature of the curbing. The younger Samuel Arnold built the Cowing house and the Wales Hotel across the street from his tavern.

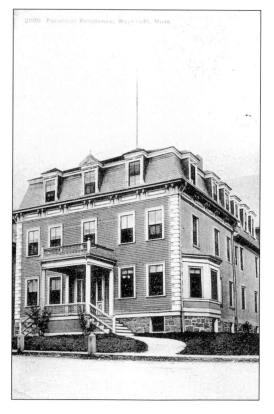

This parochial residence of Sacred Heart Church first served as a stop for stagecoach travelers, and because the railroad route approximated the stagecoach route, it served railroad travelers. The building was torn down to its foundation in the late 1900s, and a new parochial residence was built upon the old foundation. This card is postmarked 1909.

16

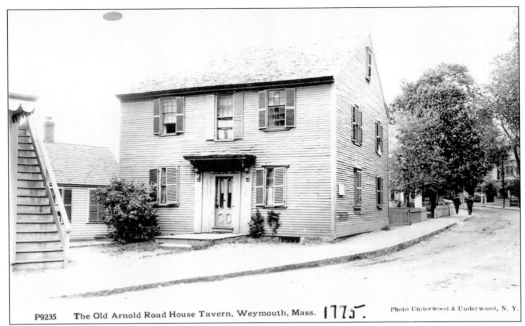

P9235 The Old Arnold Road House Tavern, Weymouth, Mass. 1775. Photo Underwood & Underwood, N. Y.

After a long, hot, dusty ride in the stagecoach, it was nice to slip out of your hotel, cross the street, and get some refreshment at the Arnold Tavern. Built *c.* 1741, the tavern was torn down in 1927 to make way for the Gem Theatre, later known as the Weymouth Theater. The site is an empty lot now.

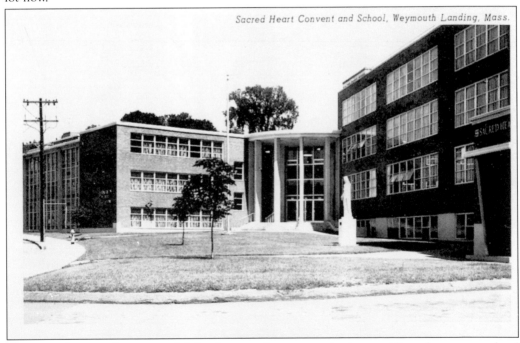

Sacred Heart Convent and School, Weymouth Landing, Mass.

The Sacred Heart Convent and School serves the community by providing elementary school education to children from the surrounding communities. The school is located on Commercial Street, to the rear of the church, and was built on the site formerly occupied by the Cowing house. The postcard dates from *c.* 1965.

17

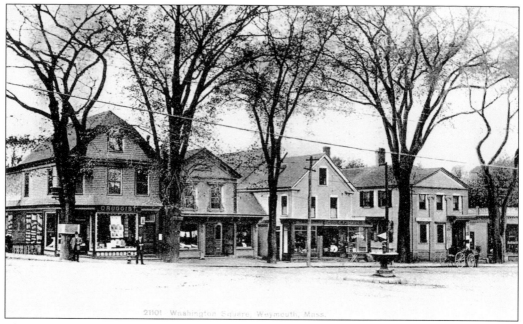

This 1890s view of Washington Square shows residential houses with businesses on the ground floor. That arrangement saved commuting time for the shopkeeper and the shopper. Notice the horse-watering trough that will reappear on other cards of Washington Square. The stately elms that once graced so much of Weymouth were lost to Dutch elm disease in the 1950s.

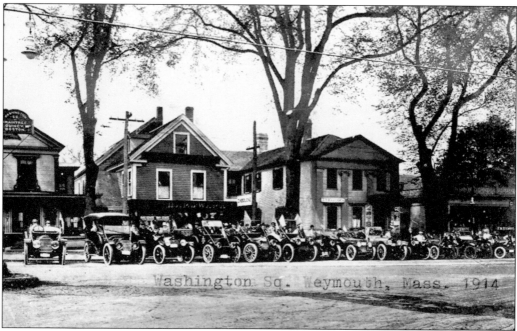

This 1914 photographic postcard shows some of the same houses as above. The elm trees still shade the area. Automobiles with their drivers and passengers are lining up for a parade or similar activity. The directional sign on the left border directs us north to Quincy, Braintree, and Boston. The sign is attached to the horse-watering trough.

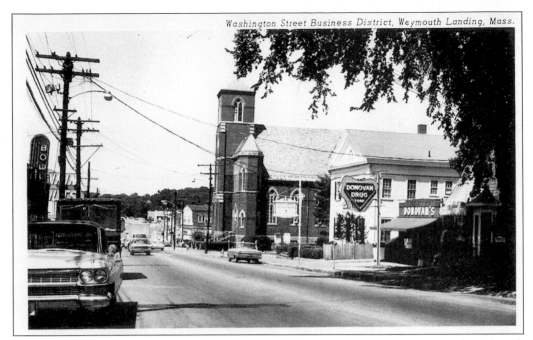

This 1965 view, looking north toward Braintree, shows the upper business district of Weymouth Landing. Sacred Heart Church now stands alone. In 1938, the First Universalist Church burned down. Its site is now a parking lot for Sacred Heart Church. In 1964, the library was taken down. Its site was used for street widening and a small town park.

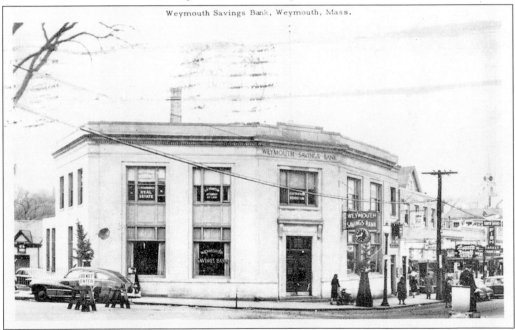

Weymouth Savings Bank, Weymouth, Mass.

The former Weymouth Savings Bank occupies the same street corner (at Front and Washington Streets) as those magnificent elm trees in the pictures on page 18. Note the policeman in the traffic control box at the bottom right of the postcard. The two towns that make up Weymouth Landing had as many as three such traffic control boxes in use at the same time.

19

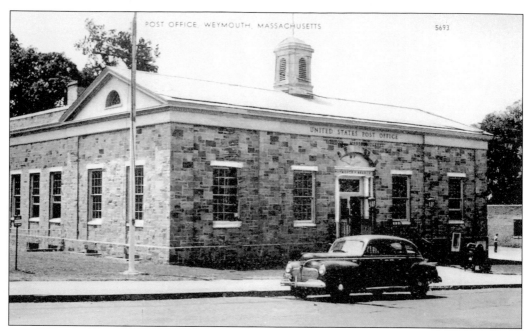

The Weymouth Landing post office stands halfway up the hill heading south from Washington Square toward Lincoln Square. It was built in 1940 from Weymouth seam-face granite. As you travel through this book, you will find several buildings with Weymouth seam-face granite construction. As you travel around town, you may notice some residential homes with seam-face granite embellishing their exterior appearance.

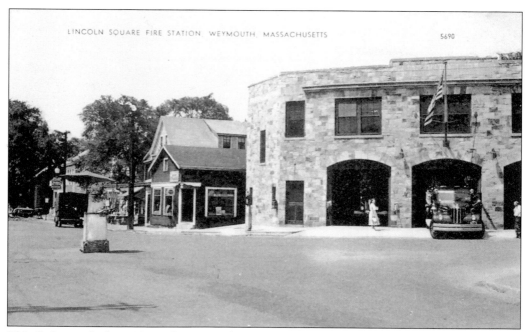

This firehouse, built *c.* 1930 of Weymouth seam-face granite, was closed in 1990 and sold to a private party. It is located in Lincoln Square, the intersection of Broad and Washington Streets. This firehouse replaced the wooden firehouse that is seen on the top of page 21.

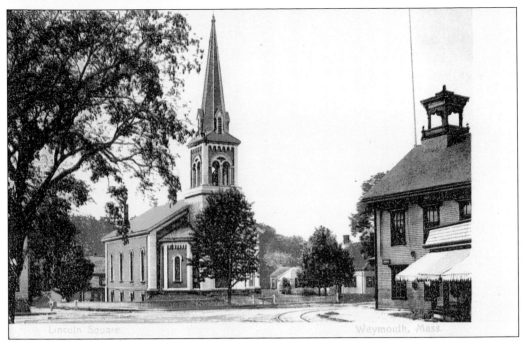

On this card, postmarked 1908, we see both the Baptist church and the wooden firehouse (built *c.* 1877) across the street. The membership of the church has built a new house of worship in South Weymouth. The South Shore Cooperative Bank now occupies the site of the church. The seam-face granite firehouse occupies the site of the wooden firehouse.

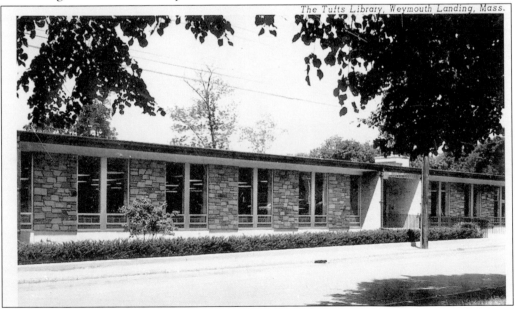

In 1964, this new and modern library building replaced the 1892 brick structure. The building is proudly constructed with Weymouth seam-face granite. This main branch of the Weymouth Tufts Library system is located on Broad Street, a short distance behind the site of the Baptist church shown above. The branches of the Tufts Library are the Fogg Library, the Franklin Pratt Library, and the North Weymouth Branch Library.

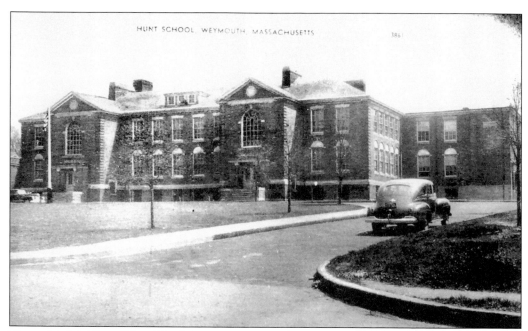

The red-brick Hunt School, built in 1915–1916, replaced the wooden school that was erected in 1881–1882. It was sold to a private party *c.* 1990, and in 1994, the South Shore Christian Academy started using it as a schoolhouse. It is still used for that purpose. The school is directly across the street from the library shown on the preceding page.

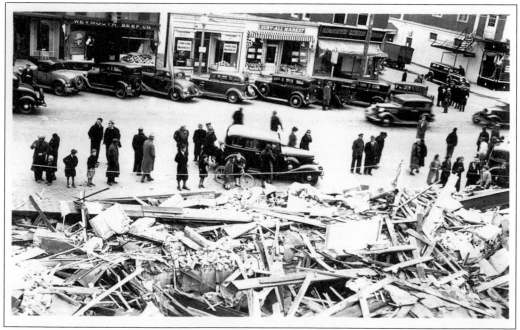

Postcards were used to convey to distant friends and relatives images of events that were of local interest but did not make national newspapers. Here we see the aftermath of a 1935 gas main explosion on the Weymouth side of the Landing. The Evergood Food Store (see page 12) was standing on the site of the explosion. There was one fatality.

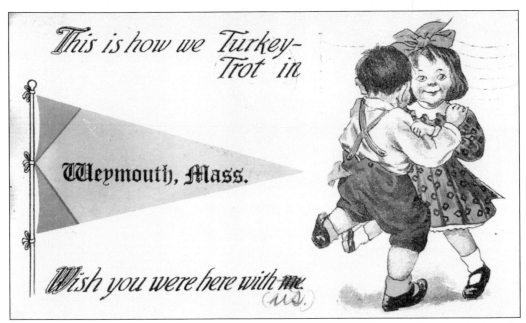

Generic postcards carried a virtually unlimited variety of illustrations with an area left clear for an overprinted identification of the retailer's locale. Generic postcards with a humorous twist are still popular. This particular one was sent to cheer up a World War I soldier who was serving at Camp Kelly in Texas.

Another variety of generic postcard was the sentimental one. Another means of identifying the locale was to attach a picture to the card rather than merely add an overprint. The picture added to this card is the same as the top card on page 16.

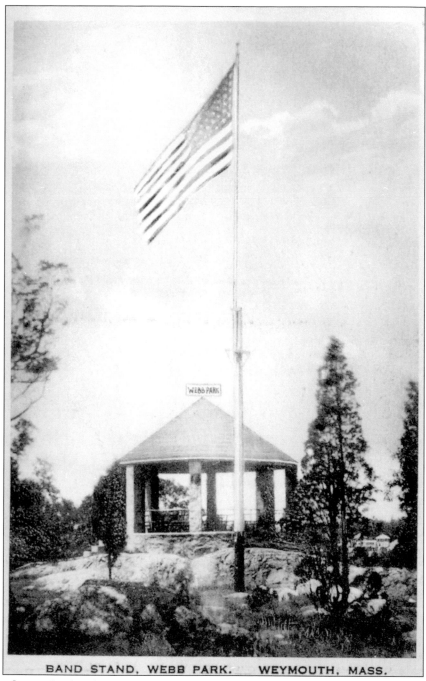

BAND STAND, WEBB PARK. WEYMOUTH, MASS.

A 48-star flag and a bandstand mark the pinnacle of the three-acre Webb Park. The land for the park was donated to the town by the descendants of Samuel Webb, a prominent citizen of the town. Postcards often remind us of an era in our history when bandstands and concerts in the park were commonplace. On this postcard from the 1915–1930 era, we see a reminder of that period. This town park is situated between Gibbens Street, Summit Street, and the railroad right of way. Do not confuse it with the William Webb State Park at the tip of Eastern Neck, commonly referred to as the Fort Point Peninsula.

Two

WEYMOUTH HEIGHTS

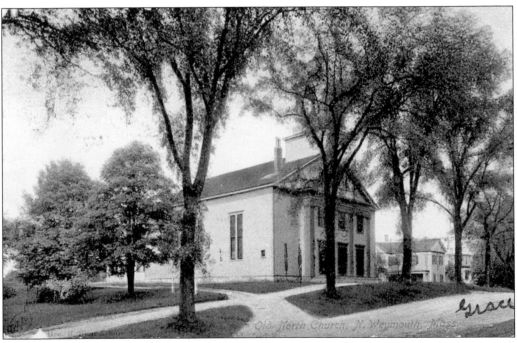

This card of Old North Church (now known as the First Church in Weymouth) shows us much of the town's history. The lawn to the left was the site of Weymouth's first schoolhouse. The elm trees that were so common around the town are gone. The road (Church Street) has been lowered for the convenience of automobile traffic. The house just to the right of the church now contains the church office. The church was gathered in 1623. This building was erected in 1833. The card is postmarked 1907.

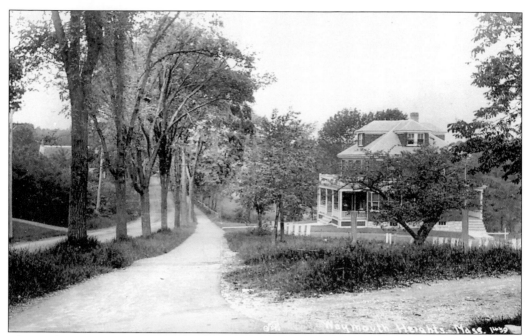

This is Church Street *c.* 1912. The house in the center of the picture still stands there at the corner of Farren Road. The elm trees are gone, and the neighborhood has developed into a residential area. The photographer is standing near the edge of the church's property, looking southwest.

This postcard from the 1990s illustrates the John Adams School. The school is located directly across the street from Old North Church, which is illustrated on the previous page. This *c.* 1853 two-room schoolhouse was North Weymouth High School (1859–1862) and is on the National Register of Historic Places. It still serves the educational needs of the community as the Just Right Child Care Center.

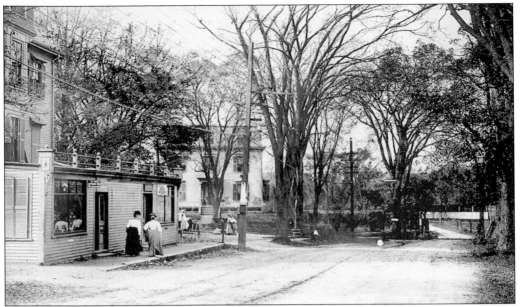

North Street passes under the railroad bridge on its way to North Cemetery. Church Street, the site of First Church and the John Adams School, enters on the left. Two women pedestrians are elegantly dressed. The sheep grazing in the window of the general store are actually reflections of sheep grazing in the field across the way. The card is postmarked 1910.

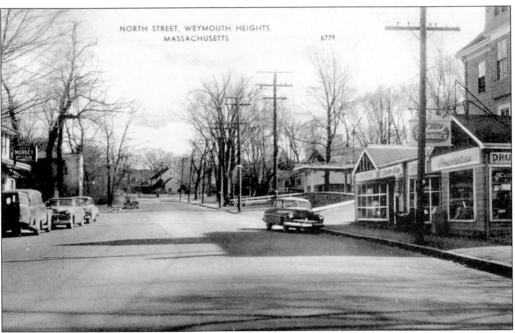

Looking south on North Street, we see the same stores as above, but 50 years later. We are looking up King Oak Hill. Joe's Market, on the left, is gone. The lot is being developed as of this writing. Beyond that is the Weymouth Heights Club building. The club has sponsored Boy Scout Troop No. 2 since 1939.

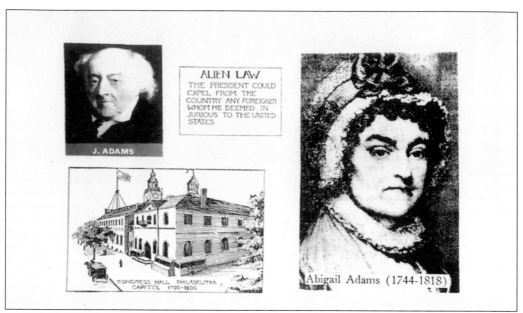

Abigail Smith, daughter of the minister of Old North Church, was born in Weymouth Heights in 1744. There she was raised, courted, and married to John Adams (see inset) of nearby Quincy. They became the parents of John Quincy Adams. For many years, Abigail was the only woman who was married to one president and the mother of another president. Today, she shares that honor with Barbara Bush.

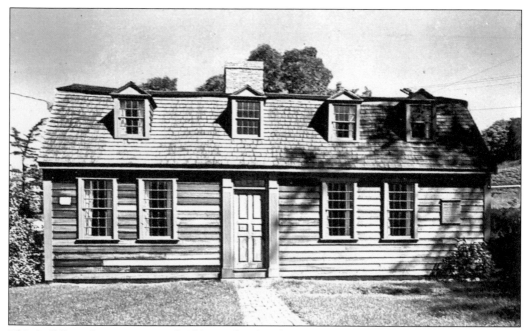

This building, the parsonage of Old North Church in 1744, is where Abigail Smith was born. Abigail's husband, John Adams of Quincy, became the second president of the United States. Their son, John Quincy Adams, became the sixth president of our nation. The building was restored by the Abigail Adams Historical Society. This glossy postcard dates from *c.* 1960.

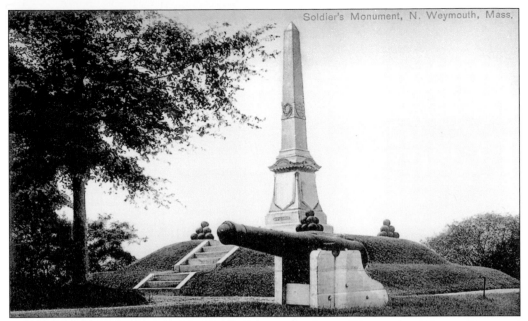

In 1868, a memorial was erected in North Cemetery to honor Weymouth residents who served in the Civil War. In 1898, the U.S. Navy donated historic cannons to further memorialize Weymouth's veterans. The postcard is from the full-photo era (1907 to 1920).

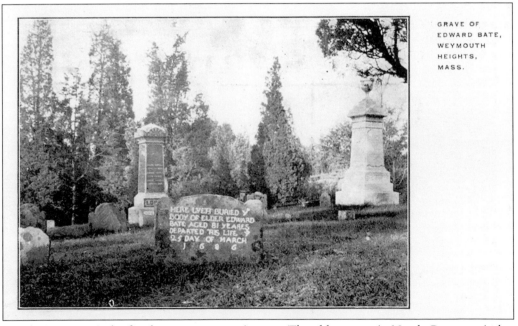

GRAVE OF
EDWARD BATE,
WEYMOUTH
HEIGHTS,
MASS.

North Cemetery is the first known cemetery in town. The oldest stone in North Cemetery is that of Elder Edward Bate, who was born in 1605 and died in 1686. The earliest burials had no grave markers so that the natives would not know the extent of the colonist losses. Later grave markers, made of wood, have long since deteriorated. The card dates from *c.* 1910.

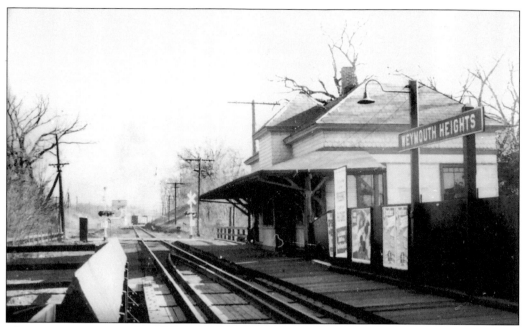

The Weymouth Heights railroad depot was located diagonally across the street from the shops seen on page 27. It is seen in this *c.* 1950 photographic postcard. A freight train disappears in the distance. Train service on this rail line stopped in the late 1950s but is currently being restored.

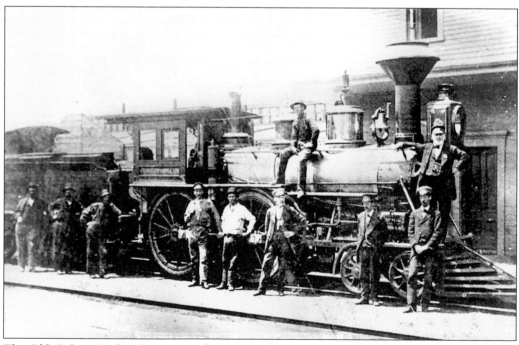

The Old Colony Railroad was one of a variety of railroad companies that provided train service to Weymouth Heights. Seen is an old steam engine and its crew in the early part of the 20th century. Train service arrived in Weymouth in the 1840s and was discontinued in the 1950s. In 1997, train service from Boston to South Weymouth resumed.

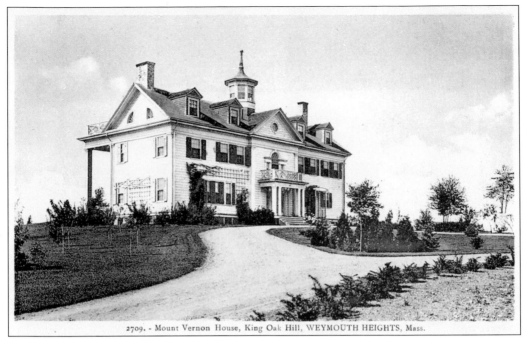

2709. - Mount Vernon House, King Oak Hill, WEYMOUTH HEIGHTS, Mass.

Although not an exact replica of George Washington's Mount Vernon, the home illustrated on this card bears such a striking resemblance to it that it carries the same name. The home, built *c.* 1905, still stands on the crest of King Oak Hill (which has an elevation of 166 feet) and is privately owned and occupied. The card is from the white-border era.

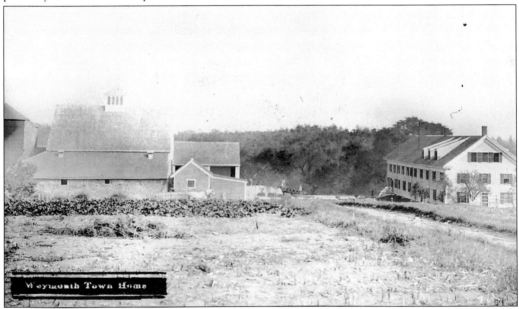

Weymouth Town Home

Over the years, this municipal complex was known as workhouse, poorhouse, infirmary, town farm, or almshouse. Whatever its name, the town of Weymouth kept such a place for the purpose of caring for its less fortunate citizens. This postcard gives us a glimpse of the "Town Home" as it appeared *c.* 1915. The Weymouth Housing Authority now utilizes this Essex Street site for residential housing.

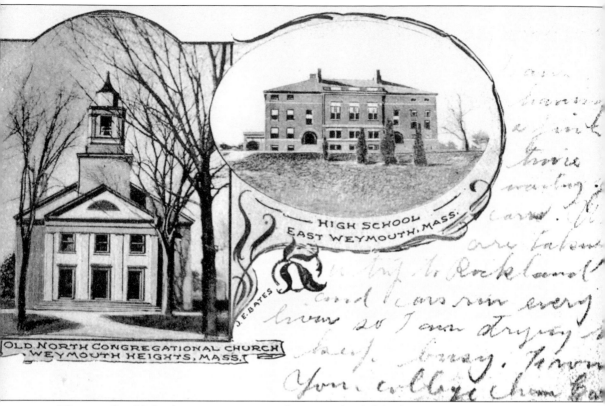

The use of multiple pictures was commonplace in undivided-back-era (1901 to 1907) postcards. A photograph of the Old North Congregational Church is combined with one of the newly built (1898) high school to make this early-20th-century card. The message on the card reads, "Dear Florence, I am having a fine time waiting for cars. We are taking a trip to Rockland and cars run every hour so I am trying to keep busy. From your college chum, Carrie."

Three

NORTH WEYMOUTH

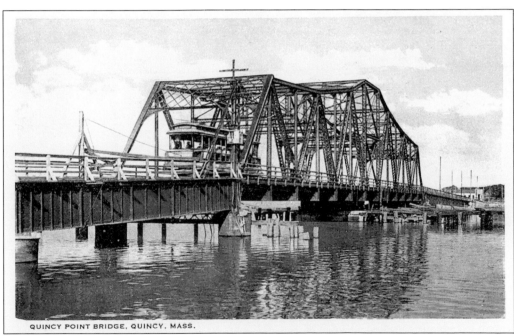

QUINCY POINT BRIDGE, QUINCY, MASS.

Thomas A. Watson (of telephone fame) was the founder of Quincy's Fore River Shipyard in 1884. Watson decided to move his shipyard, then located on the Braintree side of Weymouth Landing, farther downstream to Quincy Point *c.* 1900. One of the problems he confronted was the bridge that connected Quincy Point to Ferry Point in Weymouth. He convinced the state to authorize the construction of a new bridge. Then he convinced the state to give him the contract to construct the new bridge. Watson's firm built this pivot bridge *c.* 1902.

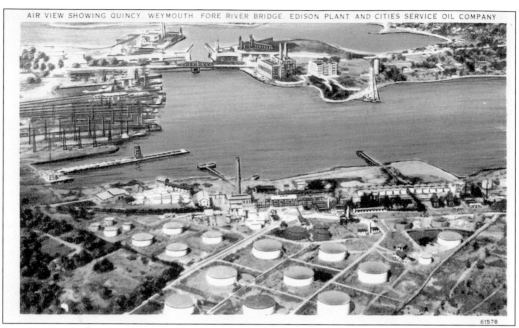

This 1935 aerial view of the mouth of the Fore River shows the 1902 pivot bridge still in place. The new double drawbridge is in the open position and not yet complete. The Cities Service gasoline storage tanks are in Braintree. The shipyard on the left is in Quincy. The Edison electric plant in the top center is in Weymouth.

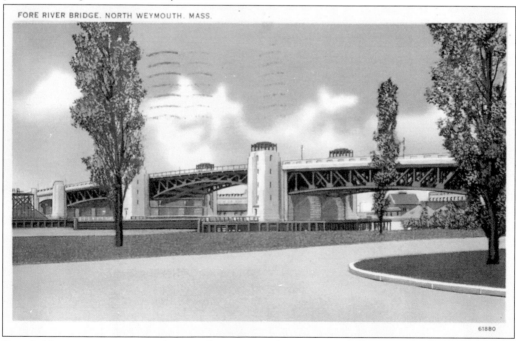

FORE RIVER BRIDGE. NORTH WEYMOUTH. MASS.

Drawbridges were constructed across the Weymouth Fore River and the Weymouth Back River c. 1812. Prior to that time, land travelers had to go around the headwaters of the rivers to make their trip from Boston to Plymouth. The double drawbridge seen here was constructed in 1935. It is in the process of being replaced with a temporary bridge. The card is postmarked 1944.

34

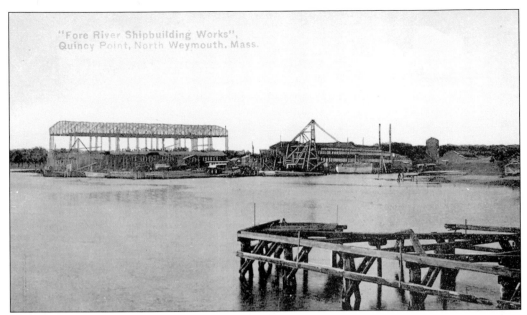

"Fore River Shipbuilding Works", Quincy Point, North Weymouth, Mass.

Although on the Quincy side of the Weymouth Fore River, Thomas Watson's shipbuilding activities were an important part of life in Weymouth. In addition to being highly visible to Weymouth residents crossing the bridge to Quincy and Boston, the shipyard provided employment opportunities for generations of Weymouth residents. A portion of the yard is the home of the USS *Salem,* a heavy cruiser launched there in 1947.

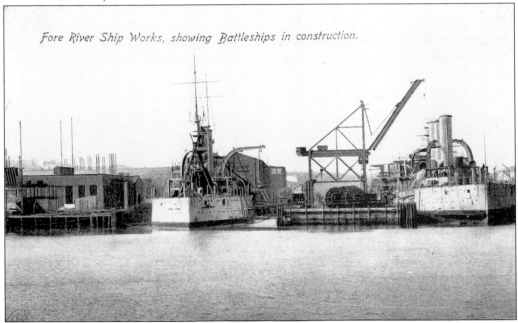

Fore River Ship Works, showing Battleships in construction.

Thomas Watson started his shipbuilding activities in the Braintree portion of Weymouth Landing in 1884. In 1903, he moved those activities downstream to the Fore River Bridge area. The shipyard changed owners several times and evolved into the second largest in the country. It ultimately closed in 1986. It is now the home of several enterprises. The postcards on this page are from the full-photo era (1907 to 1920).

Across the water is Lovell's Grove, a popular late-19th-century recreational area on the Weymouth side of the Fore River. There was a great variety of entertainment facilities available, including dance halls, restaurants, swimming, billiards, swings, tilting boards, flying horses, and bowling. Lovell's Grove declined in popularity when Paragon Park opened in 1905. The low bridge on the far left indicates that the photograph used was taken before 1902.

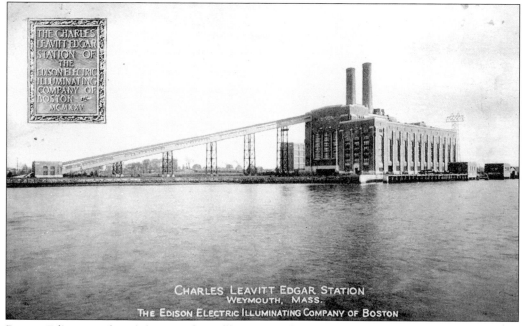

Boston Edison purchased the site of Lovell's Grove and, in 1925, built this power-generating plant. They changed the contour of the land. The plant served into the 1970s and was taken down in the late 1990s to make room for another power-generating plant.

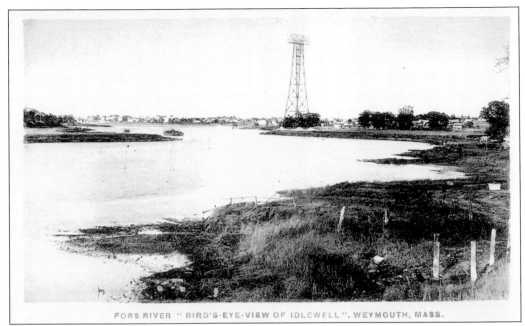

FORE RIVER "BIRD'S-EYE-VIEW OF IDLEWELL", WEYMOUTH, MASS.

Between Weymouth Landing and the Fore River Bridge area is a residential section of Weymouth known as Idlewell. Originally built for vacation homes, the neighborhood is now year-round residential. This white-border postcard shows an electric tower holding high-voltage wires emanating from the nearby electricity-generating plant.

The large building seen here is part of Nathaniel Porter Keene's shipbuilding yard on Fore River Road at the foot of Sea Street. The yard prospered in the 1870s and 1880s. It is generally believed that the original 1622 settlement of Weymouth was situated near this site. Keene lived at the corner of Bridge Street and Moulton Court (now Moulton Avenue), a short distance from his shipbuilding yard.

If you liked the Wessagusset Beach area, you could go to the Hunt's Hill House (seen on the far right) and rent a place to stay. If all that salt air made you hungry, refreshments were available in the next cottage. Many cottages in the beach area were available for rent by the week, month, or season.

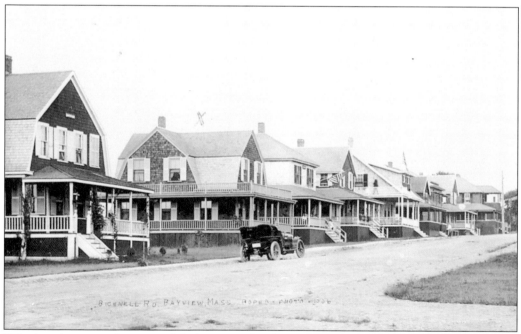

Whether they rented or owned their cottage by the sea, vacationers enjoyed seeing the cottage on a postcard and sending the card to a friend or relative. This is a view of Bicknell Road in the Bayview section of North Weymouth. Bayview is near the end of Sea Street. The X marks the cottage where the author of this card, Rena, stayed in early October 1915.

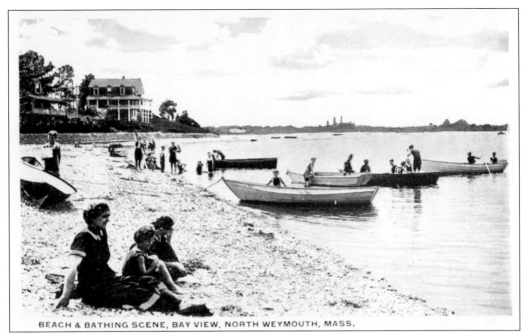

BEACH & BATHING SCENE, BAY VIEW, NORTH WEYMOUTH, MASS.

This is a typical beach scene along Wessagusset Beach, formerly Ford's Beach. Rowing, wading, fishing, and sunbathing were popular recreational activities all along the Weymouth waterfront and still are. Bathing suits of the era made swimming awkward. Creation of federal, state, and local seashore parks are indicative of the popularity of Weymouth's coastline. This card is from the white-border era (1915 to 1930).

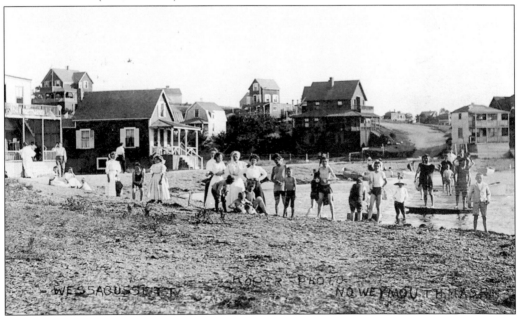

In addition to the commercial and industrial maritime history that the ocean has created for the town, vacationers have also been a part of the town's history. On this c. 1915 postcard, we see beachgoers and vacationers pose for a photographer on Wessagusset Beach. Wessagusset is the Native American name for the area we know as Weymouth.

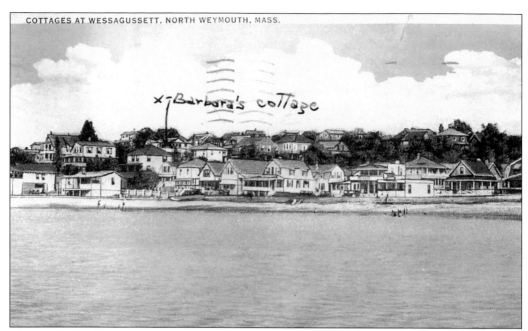

x-Barbara's cottage

The sender of this card, Barbara, chose to rent a cottage for a week and proudly shows the recipient of the card where she stayed and where she went swimming. Postcards have a long shelf life. This card from the white-border era is postmarked July 25, 1945. World War II is about to end. Postwar prosperity and the telephone are about to diminish the popularity of postcards.

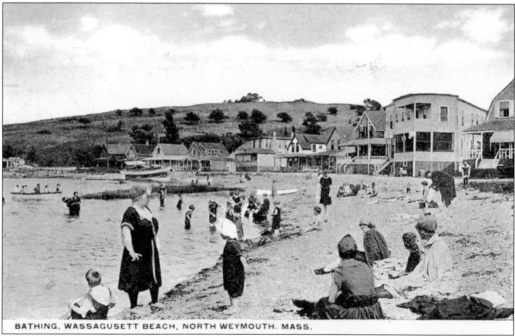

BATHING, WASSAGUSETT BEACH, NORTH WEYMOUTH, MASS.

This postcard from the white-border era is postmarked 1917. It gives a general view of bathers at Wessagusset Beach. The hill in the background is Weymouth Great Hill (with an elevation of 153 feet), now a town park, but it was a cow pasture at the time of this photograph. At one time, much of Great Hill was owned by the Bradleys, of Bradley Fertilizer fame.

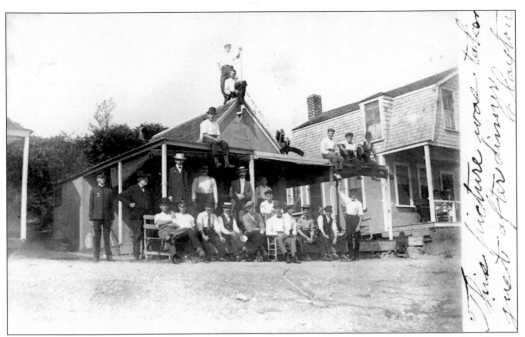

The message on the front of this postcard reads, "This picture was taken just after dinner. Clayton." The message on the back says, "This is the S. of V. (Sons of Veterans) outing at North Weymouth. Sunday, September 13, 1908." Renting a summer cottage in Weymouth was a popular vacation. Almost all of Weymouth's recreational summer homes have been converted to year-round residences.

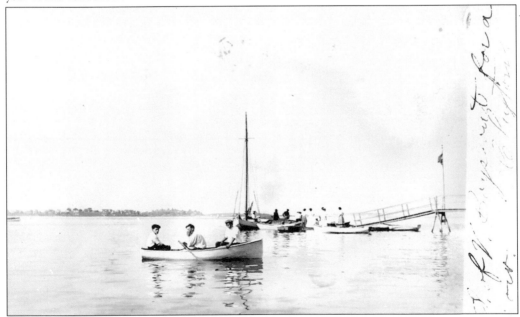

This is another postcard from the same outing. The message on the front of this card reads, "S. O. V. boys out for a row. Clayton." Notice the long, light-colored dresses of the women standing on the dock. Most of the men have headwear. Note how calm the harbor can be in late summer.

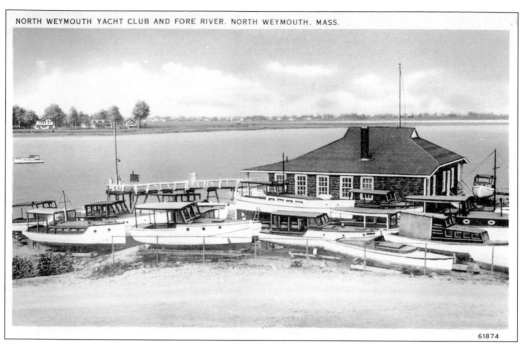

61874

This card shows the North Weymouth Yacht Club, established in 1914, located at the eastern end of King Cove on Birchbrow and Fore River Avenues. With eight and a half miles of tidal shoreline, marine activities are still an important part of Weymouth. The card is from the linen era (1930 to 1944).

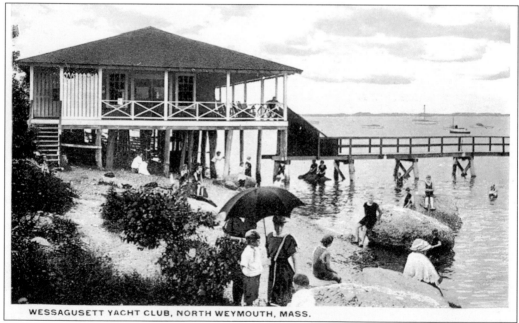

WESSAGUSETT YACHT CLUB, NORTH WEYMOUTH, MASS.

This linen-era card shows the Wessagusset Yacht Club, located on Wessagusset Beach. The club was incorporated in 1902. The clubhouse was built *c.* 1910. Both the Wessagusset and the North Weymouth yacht clubs appear frequently in the background of Weymouth's beach postcards. The Wessagusset Yacht Club still serves the Weymouth waterfront.

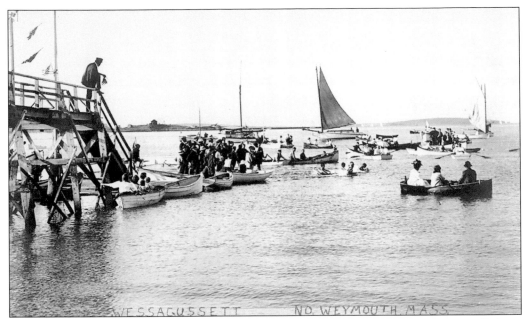

Itinerant photographers would take photographs, have them converted to postcards, and sell them. Roper is one such photographer whose Weymouth beach scenes are prized by collectors. This Roper photographic postcard shows the 1915 Fourth of July activities at the Wessagusset Yacht Club. The activities include swimming, rowing, and sailing from the dock. Weymouth still holds Fourth of July festivities at its waterfront.

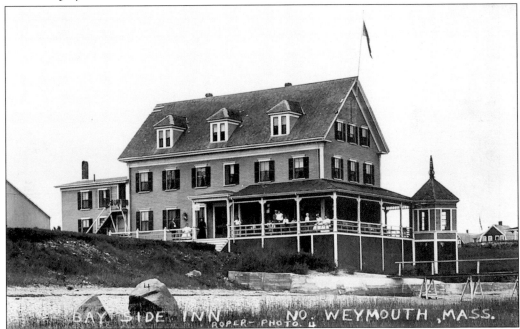

At the harbor end of Sea Street is the popular resort hotel the Bay Side Inn, built in the late 1800s. In the late 19th century and early 20th century, it was a popular landmark for tourists and residents alike. This scene is from its later years, after the building had been turned on its foundation (1906) and the gazebo added. The card dates from *c.* 1915.

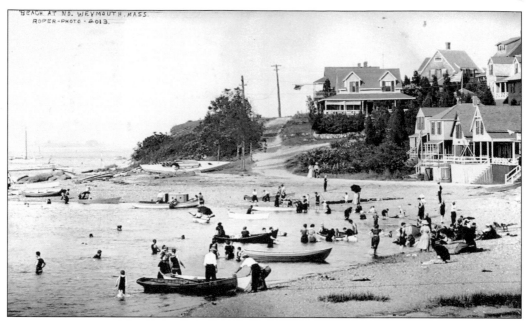

Wessagusset Beach extends from King Cove on the west to the base of Great Hill on the east. Portions of the beach have local names. This section was known as Ford's Beach. The message on the card says, "View of the beach at the foot of the street. Charlie." The street Charlie is referring to is North Street. The card is postmarked August 1912.

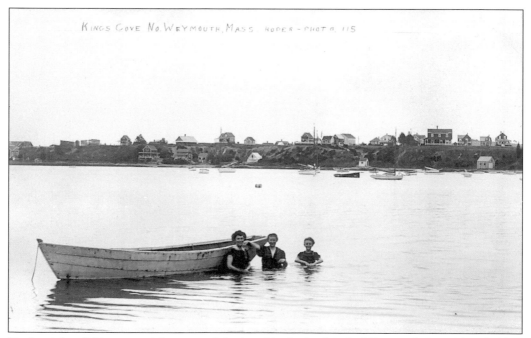

To the right of this postcard, just around the bend in the land, is the Weymouth Fore River Bridge. This sheltered cove permits its residents to enjoy a busy view of harbor and river activity and to enjoy the recreational activities of boating, fishing, and swimming. This is a *c.* 1915 card.

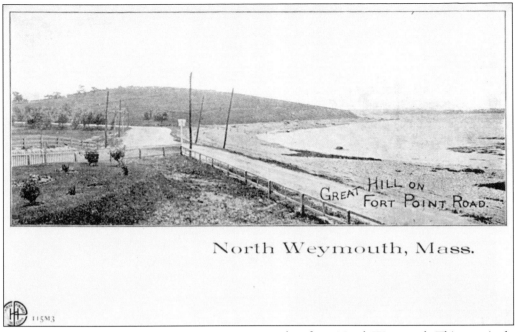

North Weymouth, Mass.

Eastern Neck is a peninsula that juts into Boston Harbor from North Weymouth. This seemingly desolate scene looks south on Neck Street where it intersects with River Street (left) and Fort Point Road (right). At the time of this card, between 1901 and 1907, Neck Street/River Street was the main artery to the Bradley Fertilizer plant, which was located partway down the neck. Great Hill dominates the horizon.

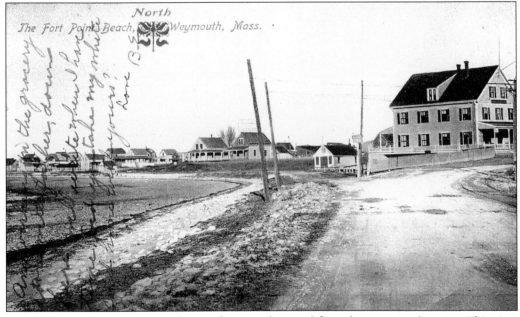

Seen is the same intersection as above a few years later and from the opposite direction. This view was taken from Neck Street. Fort Point Road goes left. River Street goes right toward the Bradley Fertilizer plant. The large building on the right is the Bower House, a popular resort inn. Notice the printer's correction in the card's caption. The postmark is 1907.

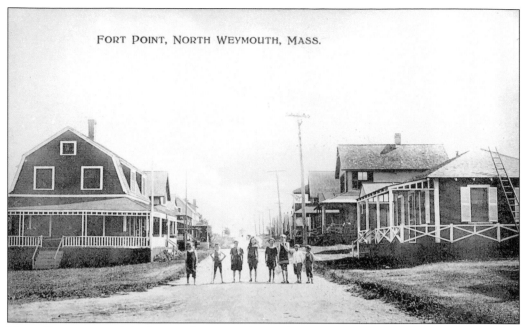

FORT POINT, NORTH WEYMOUTH, MASS.

Many, if not most, of the homes shown on this card were constructed as summer cottages and later converted to year-round residences. Renting a cottage for a week in the Fort Point section of Weymouth was a popular vacation activity in the first half of the 20th century. The children in this *c.* 1915 postcard have spotted the photographer. Boston Harbor is at the end of the road.

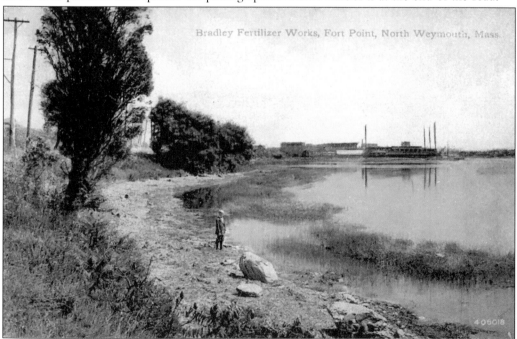

Bradley Fertilizer Works, Fort Point, North Weymouth, Mass.

A young man in knickers watches the tide recede from the Weymouth shore of the Back River. In the distance is the Bradley Fertilizer plant, which occupied part of the Back River shore of Eastern Neck. The Weymouthport condominiums were built on that site. Years later, a Nike missile base occupied the portion of Eastern Neck that is now Webb State Park.

The collector who owned this photographic postcard before us typed the caption on it. He obviously intended the date to be 1900. The business was established in 1861 and closed in the 1960s. Notice the ships at and approaching the plant, another indication of the importance of maritime activities to the economy of Weymouth.

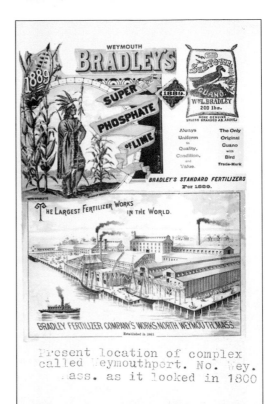

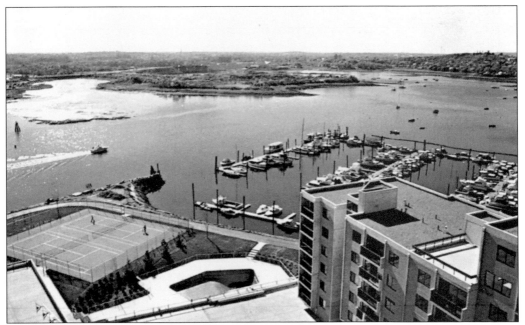

This 1970s glossy postcard shows Weymouthport, a condominium development on the site of the Bradley Fertilizer plant. The water shown is the Weymouth Back River emptying into Hingham Harbor. Although the postmark is not clear, the postage stamp used indicates that the card was mailed either in 1973 or 1974.

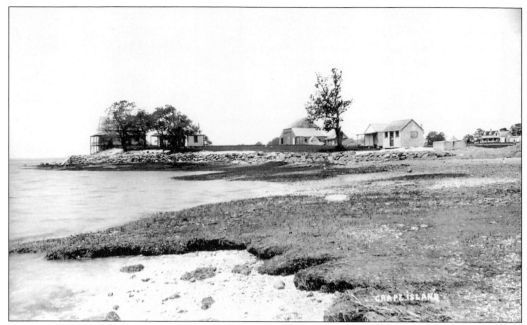

Grape Island lies about a quarter mile off the tip of Eastern Neck peninsula. On May 21, 1775, British troops attempted to gather hay from the island but were driven away by Weymouth and Hingham residents. This incident is referred to as "the Battle of Grape Island." Seen here are cottages on the island *c.* 1915. The island is now unoccupied and is part of the Boston Harbor Islands National Park.

Hingham Bridge and Cottages, North Weymouth, Mass.

The shores of the Weymouth Back River were owned privately at the start of the 20th century. The federal government took both sides of the river for national defense *c.* 1910. Today, a multitude of state and local parks lines both banks of the river. This card, postmarked 1908, shows the cottages that existed on the Hingham side of the river at the start of the 20th century.

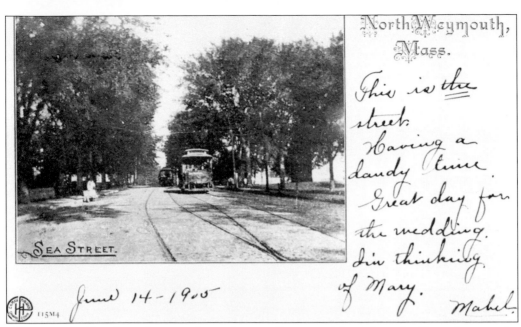

SEA STREET.

This portion of Sea Street has a moderate degree of commercial activity today. Buses from nearby Quincy still travel some of the route that these streetcars followed early in the 20th century, but buses no longer go to the beach area. This postcard, dated 1905, shows a trolley carrying vacationers to the waterfront. It is of the undivided-back variety existent between 1901 and 1907. No automobiles are visible on this card.

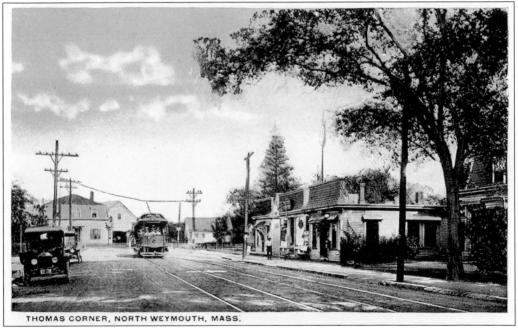

THOMAS CORNER, NORTH WEYMOUTH, MASS.

About 15 years separate the scene here from the scene above. The location is the same, but we are looking in the opposite direction. A trolley and trolley tracks dominate this scene of Thomas's Corner, the inland terminus of Sea Street. Notice that there are now cars parked in the area. Two of the three little stores on the far side of the street still provide housing for local businessmen.

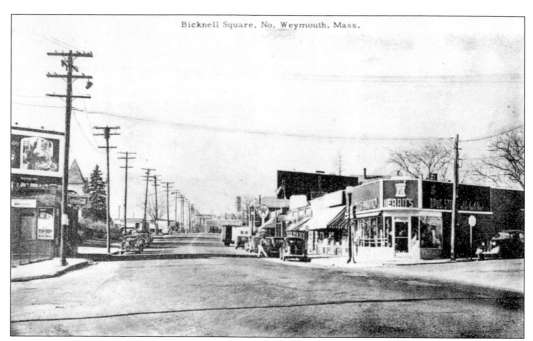

Bridge Street in Weymouth goes from the Fore River Bridge to the Back River Bridge. Partway down Bridge Street, Sea Street crosses at Bicknell Square. In this early-1940s view, looking north on Bridge Street, is the square. The trolley tracks and their related overhead wiring are gone. Hearn's drugstore was a landmark for decades.

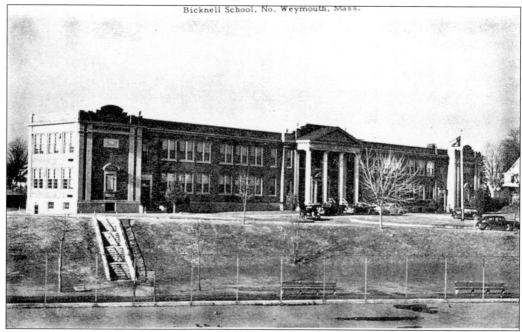

The Bicknell School still stands on Bridge Street in Bicknell Square. It is directly across the street from the site of the former Hearn's drugstore. The school was built *c.* 1930 and served as such until the 1980s. It was then sold to a private party who converted it to condominiums. The postcard is from the late 1940s.

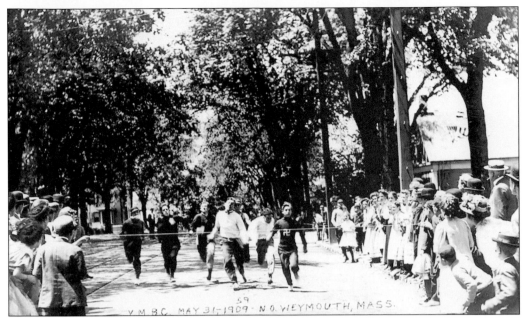

VM BC. MAY 31-1909 · N.O. WEYMOUTH, MASS.

Part of the festivities of Decoration Day (Memorial Day) 1909 was a footrace. Notice the crowd watching the young men compete. Notice also the spikes driven into the utility pole on the right. They constituted the means whereby the linemen were able to climb the pole and service the wires. How often do you see these foot spikes in Weymouth now?

St. Jerome Catholic Church, No. Weymouth, Mass.

In 1880, a small chapel was built on the corner of Neck and Lovell Streets. It was the first St. Jerome's Church. On Palm Sunday 1914, this original church was destroyed by fire. The second church building, illustrated here, was blessed in 1915 and served the parish until it was razed in 1964. Today, a larger and more modern structure serves the parish. The card is from the late 1940s.

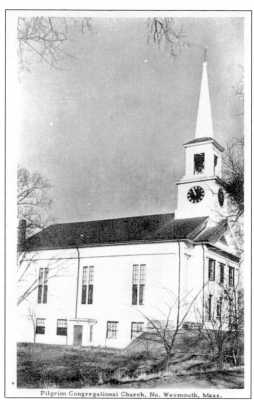

Pilgrim Congregational Church, No. Weymouth, Mass.

Because attendance at the First Congregational Church in Weymouth was so great, the members decided to start a new church rather than expand the old one. Pilgrim Congregational Church is a result of that decision. Its construction started in 1851 and was complete by 1852. Located on Athens Street, just off Bridge Street, it still serves its congregation. The card is postmarked 1963.

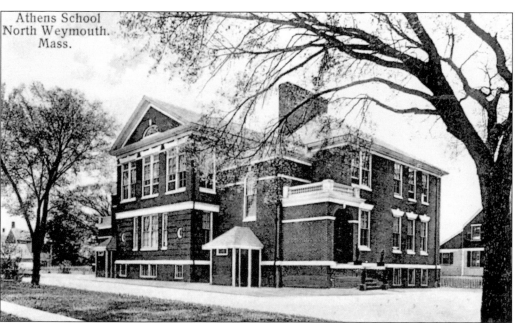

Athens School North Weymouth. Mass.

The wooden Athens School, built prior to 1871, became outgrown and dilapidated. It was replaced *c.* 1901 with the brick structure shown here. In the 1980s, like so many of the town's older schools, it was sold to a private party and converted to condominiums. It stands across the street from the Pilgrim Church.

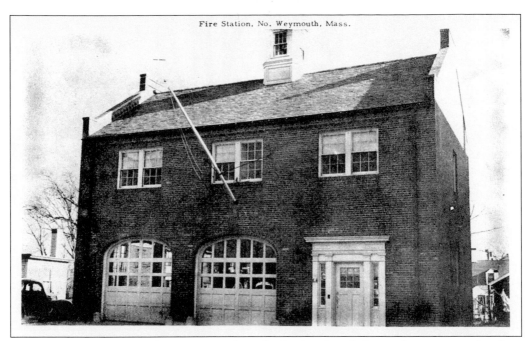

North Weymouth receives fire protection from the Station One firehouse that now stretches from Athens Street to North Street. Originally built in 1937, it was modernized in 1977. Beside it is the converted Athens School, and across the street is Pilgrim Congregational Church. This late-1940s card shows the 1937 firehouse before it was modernized.

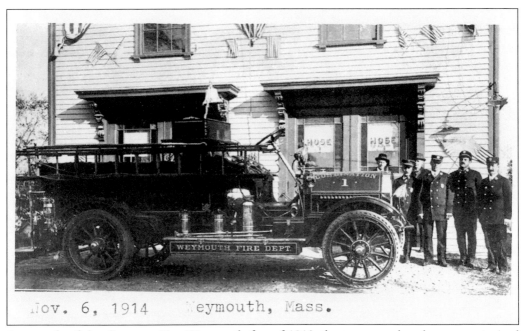

Nov. 6, 1914 Weymouth, Mass.

As a result of the disastrous East Weymouth fire of 1913, the town purchased more motorized firefighting equipment. This photographic postcard shows us Combination One (hose and ladder) as it arrives at the North Weymouth firehouse in 1914. Other motorized equipment was purchased and assigned to other parts of town.

UNIVERSALIST CHURCH, NORTH WEYMOUTH, MASS.

The Third Universalist Church of Weymouth still stands on the corner of Sea and Bridge Streets serving its congregation. It is diagonally across from the former location of Hearn's drugstore (see page 50). It was built in 1872. The members of this church maintain the heritage of Olympia Brown's leadership and her start in Weymouth. This postcard is of the undivided-back era and is postmarked 1908.

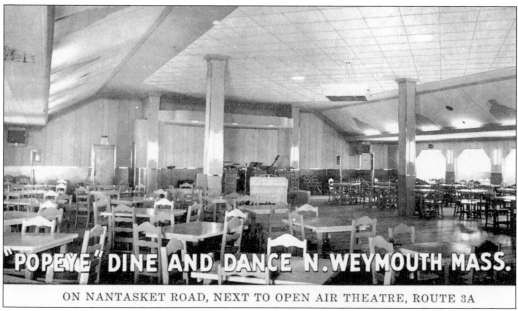

"POPEYE" DINE AND DANCE N. WEYMOUTH MASS.

ON NANTASKET ROAD, NEXT TO OPEN AIR THEATRE, ROUTE 3A

Popeye served "Food Fit for a King." It ran "continuous shows every night, also Sundays, and dancing until 1 A.M. Seating 600 persons. Open year round." Popeye was located on Bridge Street next to the Weymouth drive-in theater near the Back River Bridge. Also known as the Tent Ballroom, it was later known as Coral Gables. A McDonald's now occupies the site.

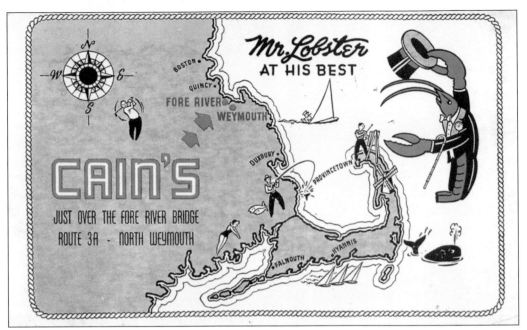

Hungry vacationers have to eat, and North Weymouth had enough restaurants to feed tourists and residents alike. Sadly, not all restaurants issued postcards. Cain's Restaurant promoted its motto, "Mr. Lobster at his best," liberally with postcards. It reminds us of an era when a local entrepreneur operated the local restaurant. Cain's Restaurant was in business before 1930 and closed in the 1970s.

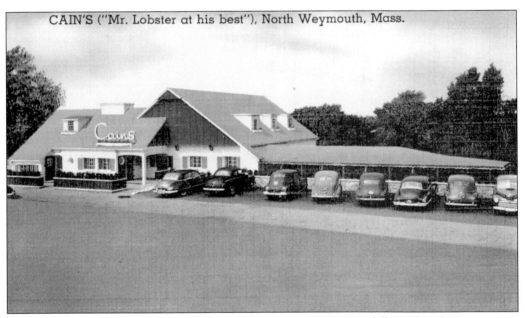

This late-1940s postcard shows us the "new from cornerstone to cupola" Cain's and an assortment of automobiles. Cain's Restaurant was situated at Bridge Street, near the Fore River Bridge. The building burned in the 1980s. One of the Dunkin' Donuts shops now serving Weymouth residents and Route 3A commuters stands on the site today.

Most towns and sections of towns had generic postcards welcoming you to their location. Just what does this cryptic message mean to the recipient or the person who sent it? The card is properly addressed and postmarked 1913. The message is blank. It is simply signed, "Uncle Frank."

Another generic greeting card invites us to remember our visit to North Weymouth and to come back and visit again. The scene illustrated could be a Weymouth scene but it is more likely not. The card is postmarked 1914.

Four

EAST WEYMOUTH

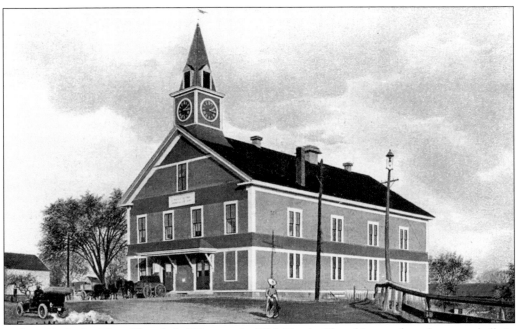

Before 1852, the First Church in Weymouth (Old North Church) served as the town hall. In 1852, Weymouth's first town hall was built at the corner of Washington and Middle Streets, the geographic center of town. The building contained a room that became Weymouth's first high school. The town hall was moved in 1907 to Pleasant Street in East Weymouth and restored on the site of the former White Church. The town hall was consumed by fire in 1913. It is seen here in its East Weymouth location.

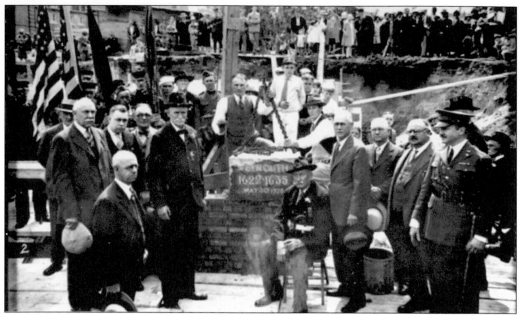

Dignitaries and veterans pose for their picture as the cornerstone of the new town hall is put in place on May 30, 1928. The cornerstone bears the dates 1622 and 1635. The date 1622 represents the settling of Weymouth as Wessagusset. The date 1635 represents a major influx of settlers and the incorporation of the town as Weymouth.

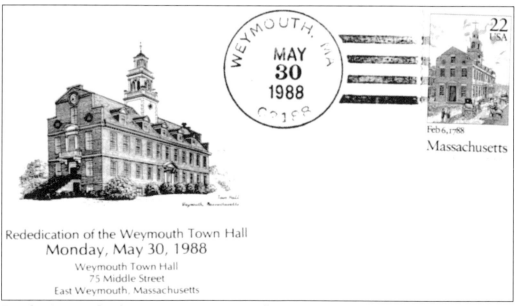

Rededication of the Weymouth Town Hall
Monday, May 30, 1988
Weymouth Town Hall
75 Middle Street
East Weymouth, Massachusetts

Exactly 60 years after the cornerstone was originally put into place, the town hall was rededicated after extensive renovations. This postcard was mailed to town residents as a reminder and souvenir of the event. The postage stamp affixed contains an image of the Old State House.

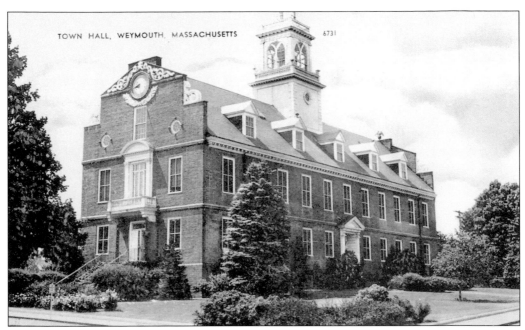

The current town hall stands majestically in "full dress uniform" in this *c.* 1940 postcard. Notice the gingerbread around the sundial, the ornamentation on the steps of the gable, and the two circular windows. On the far end of the building an eagle clutches a globe. The town hall is modeled after the Old State House.

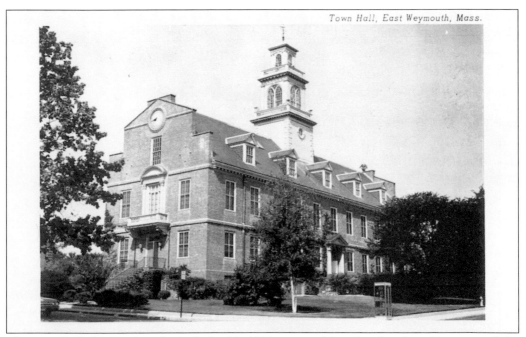

Town Hall, East Weymouth, Mass.

The town hall also stands majestically in this 1960s postcard, but the gingerbread is gone and the circular windows have been closed with bricks. An eagle still clutches a globe on the far end of the building. Now, at the start of the 21st century, this 1928 town hall still serves as the center of town government. Notice the telephone booth on the sidewalk.

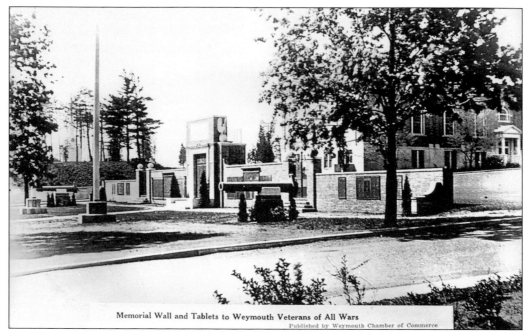

Memorial Wall and Tablets to Weymouth Veterans of All Wars
Published by Weymouth Chamber of Commerce

Memorials to Weymouth veterans were constructed in 1930. A memorial wall with tablets affixed to it remembers every Weymouth resident who has served in the military since the colonial days. The Cross of Gray (see page 61) stands on the knoll to the left of the wall. The Ralph Talbot Amphitheater is behind the memorial wall.

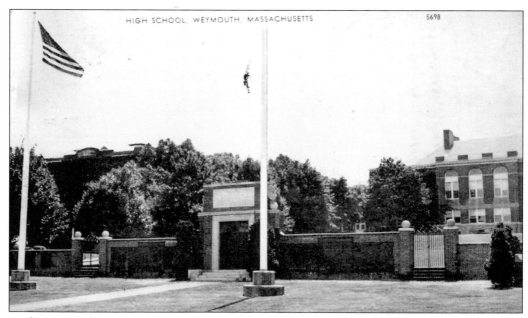

In this view of the memorial wall, an empty cannon mount in the right extremity of the card is seen. The cannons are gone. Between the wall and the 1898 high school is the Ralph Talbot Amphitheater, named for a 1915 Weymouth High School graduate who earned a Congressional Medal of Honor. A 48-star flag waves over the site. The card is postmarked 1950.

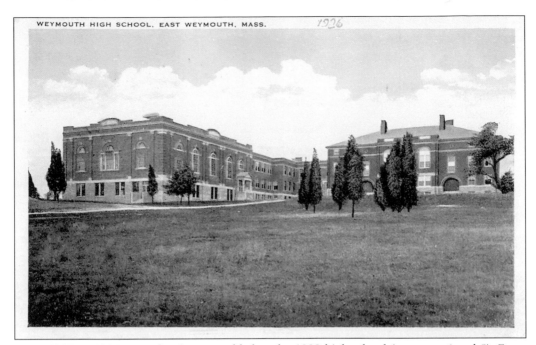

From 1923 to 1924, a south wing was added to the 1898 high school (see pages 6 and 8). From 1927 to 1928, a north wing with a tower was added to the 1898 high school. This card shows the high school as it appeared during that brief period of its history when it had only the one wing. The card is postmarked 1926.

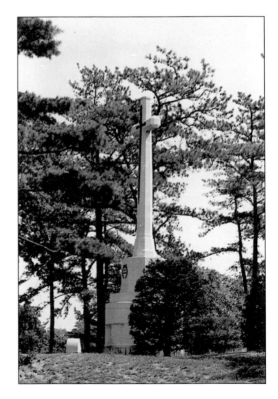

As part of the civic center construction of 1930, a memorial Cross of Gray was erected to honor the Weymouth men and women who gave their lives for their country. It stands on a pine-covered knoll next to the high school. It is seen on this glossy card postmarked 1954.

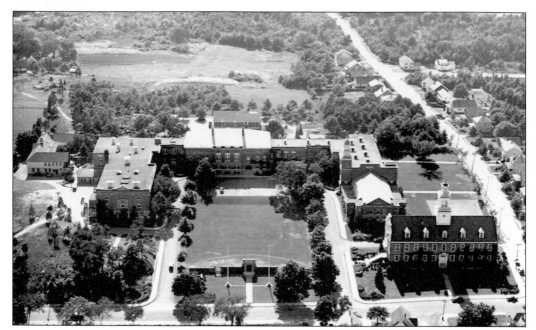

This late-1940 postcard summarizes Weymouth's civic center. In the right foreground is the town hall. The 1898 high school, with the two wings added in the 1920s, dominates the center. The Ralph Talbot Amphitheater is the grassy expanse in front of the high school. The memorial wall stands across the front of the amphitheater. The Cross of Gray stands on the knoll to the left.

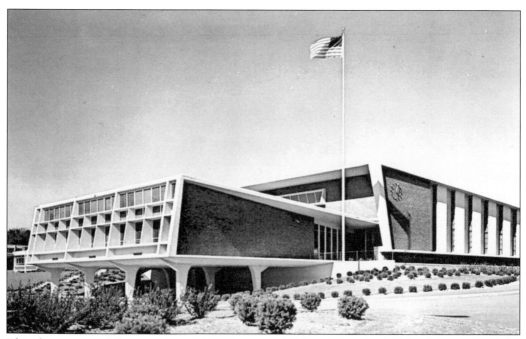

This glossy postcard shows us the *c.* 1963 Weymouth High and Vocational School that replaced the 1898 high school. The building, which was constructed to accommodate 2,000 students, covers 5 of the 16.5 acres that constitute the campus. This school is located on the old stagecoach route, Commercial Street in East Weymouth.

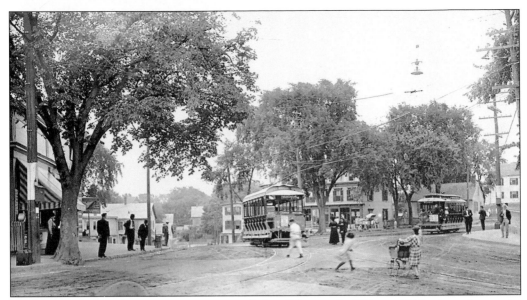

Jackson Square is the economic center of East Weymouth. This *c.* 1910 view shows the intersection of Commercial and Broad Streets. The trolley on the left is arriving from Hingham; the one on the right is the South Weymouth trolley. Notice the baby carriage and the clothing of the pedestrians. George H. Hunt & Company (see page 65) published this commercially prepared photographic postcard.

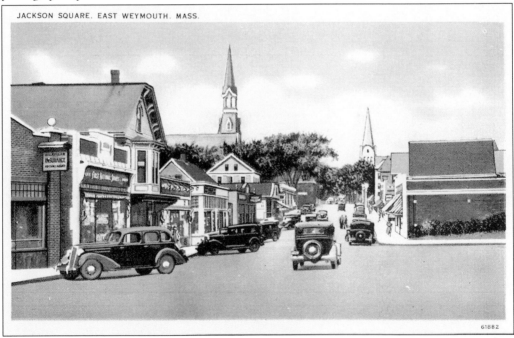

Looking in the opposite direction as the previous card, this view shows Jackson Square in the 1930s. The steeple of the First Methodist Church is on the left; the steeple of the Immaculate Conception Catholic Church is on the right. Both churches have replaced their buildings. Most of the businesses have changed, but the commercial buildings are pretty much the same today. The card is from the linen era (1930 to 1944).

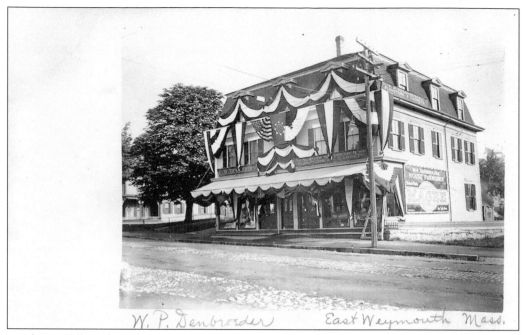

In the middle of Jackson Square was Denbroeder's haberdashery. Denbroeder's provided men's wear, tailoring, and small wares for the community for over 60 years. Here, the store is appropriately decorated for the Fourth of July. The card is from *c.* 1910. The building is still in use as a residence and commercial outlet.

This postcard shows Jackson Square at the start of the 20th century. The D. Ghiorzi confectionery signs advertise the sale of fruits, produce, cigars, tobacco, and Moxie and that he has a lunchroom. Ghiorzi's neighbor sells ice cream and has a public pay telephone. A young boy in knickers leans against a pole. The card is postmarked 1911.

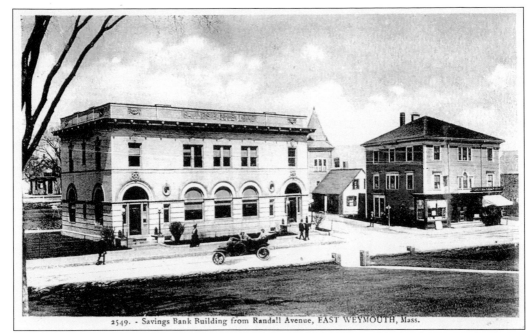

2549. - Savings Bank Building from Randall Avenue, EAST WEYMOUTH, Mass.

The focus of this postcard is the savings bank building. The steeple of the Unitarian church is just to the right of the bank building. A residence separates Hunt's "newsroom on the corner" from the Unitarian church. George H. Hunt & Company, a newspaper dealer, was a major publisher of Weymouth postcards. Notice the overprinted automobile. The card is postmarked 1916.

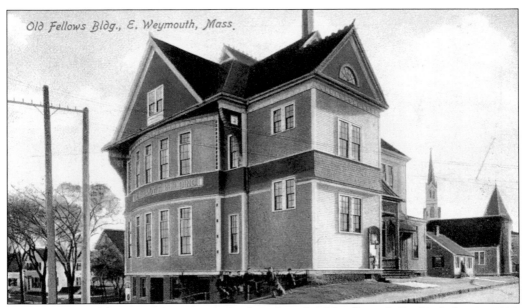

Old Fellows Bldg., E. Weymouth, Mass.

Crescent Lodge No. 82 of the International Order of Odd Fellows built this lodge in 1888. In the 1930s and 1940s, a motion picture theater, Jason's, operated in the building. Notice the bulletin board telling people what is playing. The Methodist church steeple is on the horizon. The Unitarian church can be seen on the right. Since then, the upper floor of the Odd Fellows building has been removed.

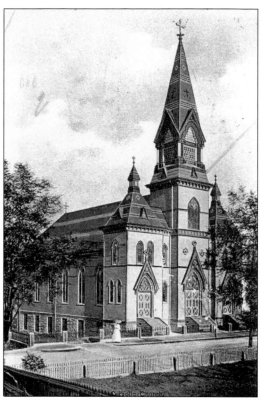

When St. Francis Church was destroyed by fire in 1869, Fr. Hugh Smyth decided to build several smaller churches to serve the Catholic population of Weymouth. The Immaculate Conception Church, built *c.* 1873, was one of them. It was located west of Jackson Square, on the site of Randall's Hall and the Canterbury shoe factory. It served the parish until 1967, when it was replaced with a modern building.

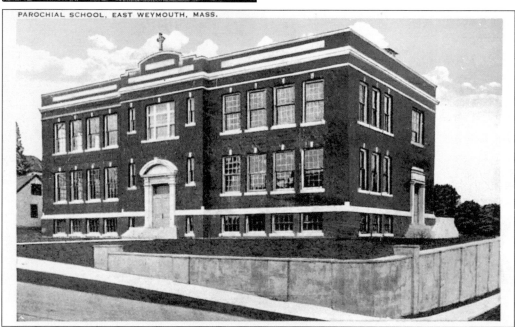

The parochial school building of the Immaculate Conception Church is located behind the modern church at the intersection of Madison and Commercial Streets. The church operated this elementary school for nearly 50 years, from 1925 to 1973. Today, the school is used for religious education and general parish purposes. The postcard is of the white-border era (1915 to 1930).

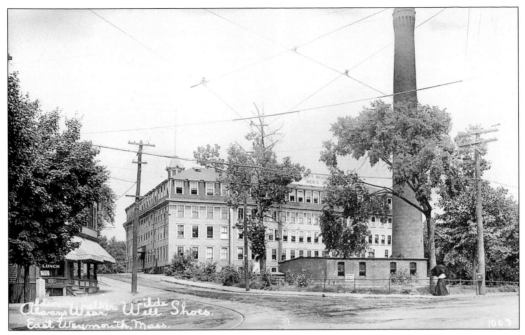

In 1861, M. C. Dizer built this shoe factory at the intersection of Broad and Madison Streets. In 1910, he sold the factory to Alden, Walker, and Wilde, shoe manufacturers. Their motto, "Always Wear Well Shoes," corresponds with the company's initials. Notice the overhead trolley wires and the trolley tracks turning down Madison Avenue. The building was taken down in 1929.

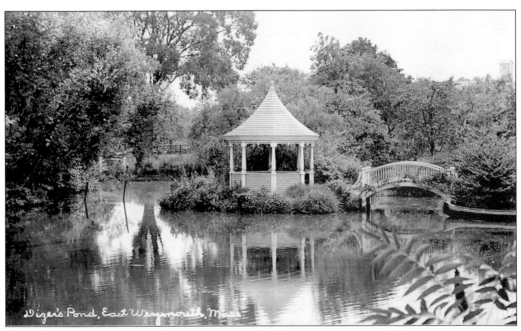

Dizer lived a short distance from his factory. On his property is a small but picturesque pond. Seen here is the entire pond with its gazebo and two footbridges. It was a favorite location for ice-skating until insurance requirements compelled its current owners to drain the pond during skating season.

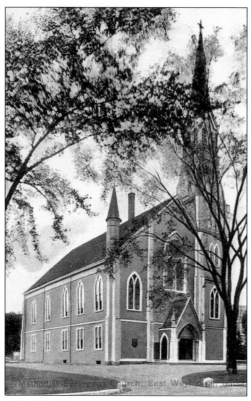

The United Methodist Church traces its history back to 1822. Their third church building was destroyed by fire in February 1870, and their fourth, the one illustrated here, was dedicated in December of the same year. On August 13, 1954, Hurricane Carol knocked down the church steeple and caused extensive damage to the church. The card is postmarked 1909.

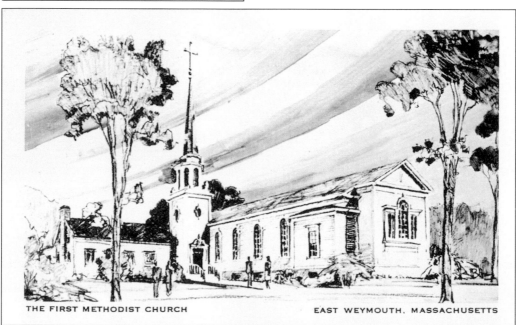

THE FIRST METHODIST CHURCH EAST WEYMOUTH, MASSACHUSETTS

Hurricane damage was so extensive that the members of the church, using those portions of the church that were salvageable, erected a new church. The new sanctuary was dedicated in April 1958. The above card is an architect's rendering of the proposed new church. The completed church looks much like the drawing.

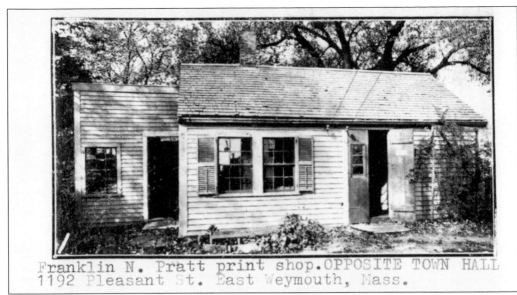

Franklin N. Pratt print shop. OPPOSITE TOWN HALL 1192 Pleasant St. East Weymouth, Mass.

Franklin N. Pratt was the Boy Scout leader for Troop 2, Weymouth, for more than 35 years. His occupation was printer, and this photographic postcard shows his print shop. It was situated across the street from the relocated original town hall (see page 57). Pratt left the print shop and its land to the town's library system, and the town has constructed the Franklin Pratt Branch Library on the site.

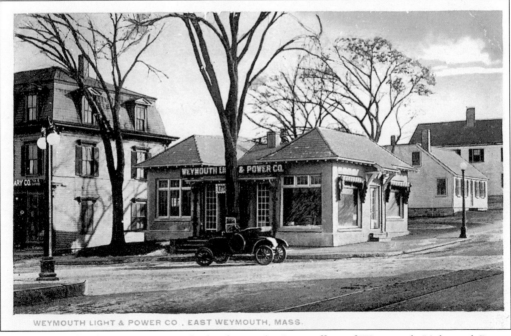

WEYMOUTH LIGHT & POWER CO., EAST WEYMOUTH, MASS.

At one end of Jackson Square stands the former business office of Weymouth Light and Power Company. The company has long since been absorbed into a large electric conglomerate. The building still stands, with a significant addition. The building to the left has been razed and is now the site of the East Weymouth post office. The Pleasant Street houses in the background still stand. The card is postmarked 1918.

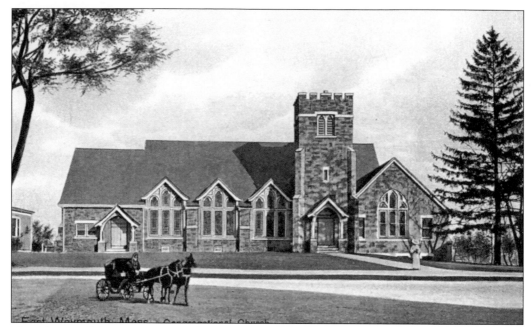

The history of the East Weymouth Congregational Church traces back to 1822. In 1903, fire destroyed their White Church, which had been built in 1843. The congregation replaced its White Church with the building illustrated on this card. Located in the heart of Jackson Square, this 100-year-old building, made of Weymouth seam-face granite, still serves the community.

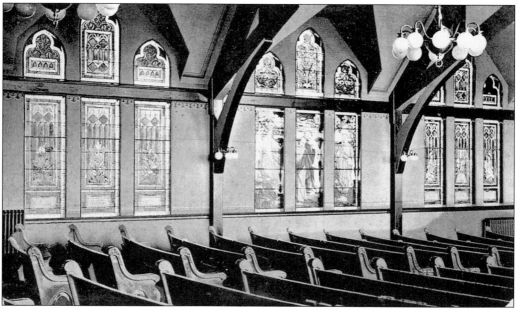

After the beloved White Church burned, the members of the East Weymouth Congregational Church chose to relocate their church to a better location. Consequently, they purchased from Albert Humphrey land that was conveniently located across from Ghiorzi's confectionery store (see page 64). An interior view of the East Weymouth Congregational Church shows the fine carpentry used in its construction, its chandeliers, and its stained-glass windows. The card is dated 1920.

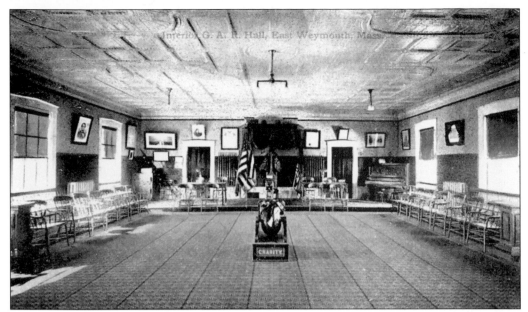

The building at 1207 Commercial Street began its career as a district school, the Bicknell. It became the Grand Army of the Republic Hall, Reynolds Post No. 58, *c.* 1880. Seen is the interior of the meeting hall. The building is still extant but has changed significantly. The second story has been removed. It has been used as a doctor's office and is now the home of the Prudente Insurance Agency.

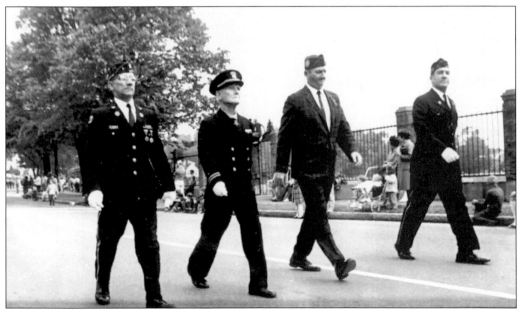

Pictured from left to right, Ray Tremblay (Chief One Bear of the Wampanoags), Bill Seach (Congressional Medal of Honor holder), Ken McNeil, and Charles Heliard march past Legion Field in the 1968 Memorial Day parade. All these men are past commanders of the Weymouth Veterans of Foreign Wars. Early settlers in town heated their homes with peat gathered from the various peat bogs in town. Legion Field was one such site.

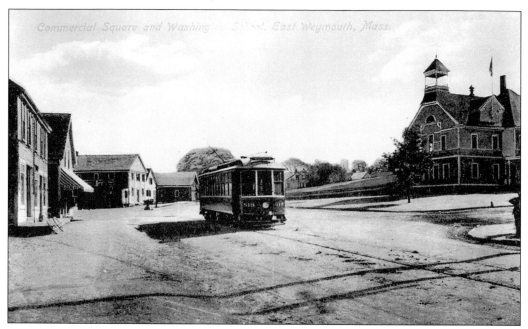

As it passes through Commercial Square, a trolley obscures our view of High Street. On the left, with the awning, is Burrell's News and Grocery Store. The Washington School stands on the right. Both buildings are still in use. Although there is no sign that says Herring Crossing, the herring do cross under this portion of the roadway en route to Whitman's Pond to spawn.

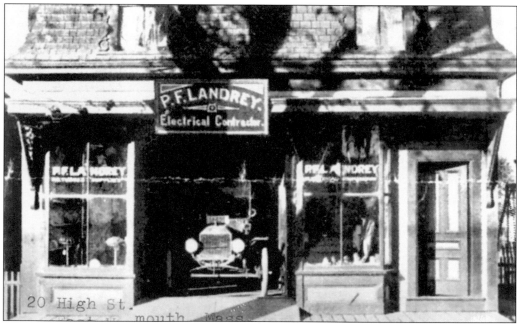

This photographic postcard shows P. F. Landry's shop and motor vehicle. Landry, an electrical contractor, maintained his shop at 20 High Street in Commercial Square, East Weymouth. The shop is now gone, and the site has seen a multiplicity of uses over the years. Now it is a CVS drugstore. Commercial Square is often referred to as Lower Jackson Square.

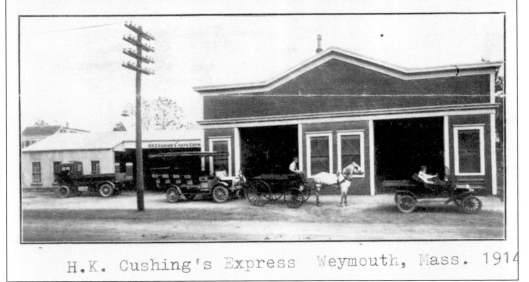

H.K. Cushing's Express Weymouth, Mass. 1914

H. K. Cushing operated an East Weymouth–Boston express twice daily. In this photographic postcard is the East Weymouth office on Commercial Street at the corner of Hill Street as the express company changes from horse-drawn wagons to motorized transportation. They advertised "Furniture and Piano Moving a Specialty." Before 1929, there was no radio or television. Piano playing at home was significantly more popular than it is now.

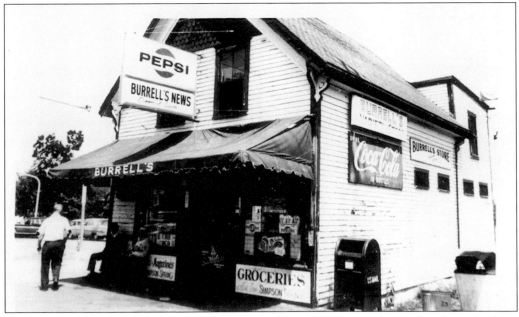

If you grew up in East Weymouth during the 1940s and 1950s, you know that the only thing better than a 10¢ ice-cream cone from Burrell's was a 15¢ cone from the same store. Burrell's was located in Commercial Square, the intersection of Broad, High, and Commercial Streets. The Burrell family has sold the store, and now Niko's Restaurant operates from the building.

Emerson Coal, wood, flour, grain & hay Co.
East Weymouth, Mass. 1886

The Emerson Coal and Grain Company was situated at the intersection of Wharf and East Streets, close to the Keith shoe factory. It served the community by delivering coal, oil, chicken food, and similar products. The date typed onto the card by the card's previous owner indicates the date the business started. The business was sold to a Quincy oil-delivery company in the 1980s.

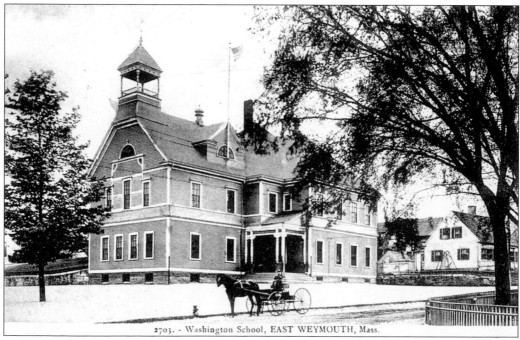

2703. - Washington School, EAST WEYMOUTH, Mass.

The Washington School, at 8 School Street in Commercial Square, was built c. 1888. Its six rooms replaced four district schools. It serves today as offices for Scilab Boston. The use of an older photograph is typical of the money-saving techniques used in the white-border era. The publisher of the card is Thomson & Thomson of Boston. The card is postmarked 1917.

At its peak, Weymouth enjoyed the presence of over 75 shoe factories. Competition, first from other local communities, then other regions of this country, and finally other countries, brought the demise of the shoe industry in Weymouth. Other businesses took their place. This card, postmarked 1913, shows Strong's shoe manufactory, at the corner of Maple and Middle Streets. The site is now occupied by the Maple Gardens Apartments.

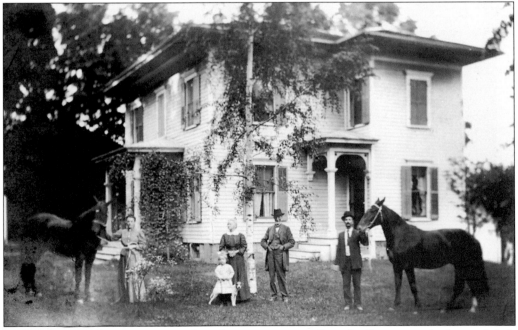

Before photography was commonplace, it was customary for a family to pose in front of their home with their prized possessions, in this case a pair of beautiful horses. Take note of the clothing styles. The notation on the reverse indicates that the Strong family posed for this photographic postcard in 1914.

SCENES ON MILL RIVER

Dear Lila,—
Allow me to congratulate you on the great event in your life, hoping you both will have a long, happy, useful life, I remain, yours truly, Alida G.

Mill River flows from Weymouth Great Pond (South Pond) along Mill Street, where it was used for waterpower, into Whitman's Pond. From Whitman's Pond it flowed into the Weymouth Back River. The herring (alewives) would swim from the ocean into the Back River, overcome barriers, and enter Whitman's Pond to spawn. This arrangement of three photographs was popular in the undivided-back era (1901 to 1907). The card is postmarked 1909.

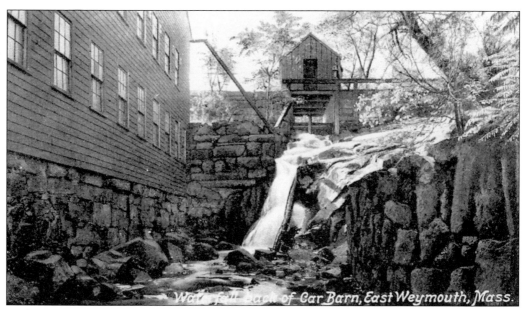

Waterfall back of Car Barn, East Weymouth, Mass.

In the 1800s, after the Mill River left Whitman's Pond, it provided waterpower to the Weymouth Iron Works. The ironworks buildings were used as garages for trolleys after the ironworks closed. The carbarns have been removed and the land is empty. The waterfall has been replaced with a herring ladder to make it easier for the herring to reach their spawning grounds.

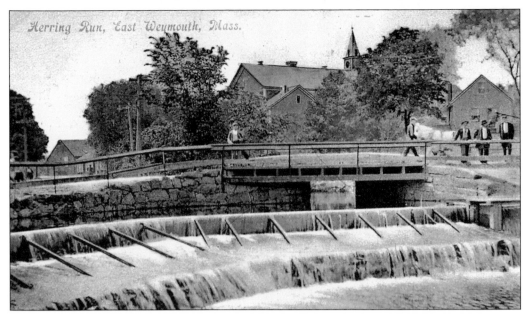

Weymouth history mentions the "herringe broge" (herring brook) as early as 1648. In 1724 and 1725, the town negotiated with mill owners "to make convenient passage for fish into Whitman's Pond." In early May, people still gather in this location (the intersection of Commercial and Water Streets) to watch the herring run upstream to their spawning grounds in Whitman's Pond. The steeple in the background belongs to the relocated old town hall.

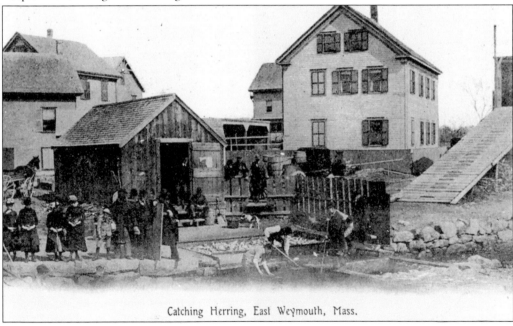

Catching Herring, East Weymouth, Mass.

At the same location as above, three fishermen gather herring as the fish swim to their spawning grounds in Whitman's Pond. The commercial and noncommercial catching of herring is no longer allowed. Circumstance, excess harvesting, and mills caused the herring to be stamped out in the late 1600s. In the early 1700s, the town restocked the herring and made arrangements with the mill owners to construct passageways for the fish.

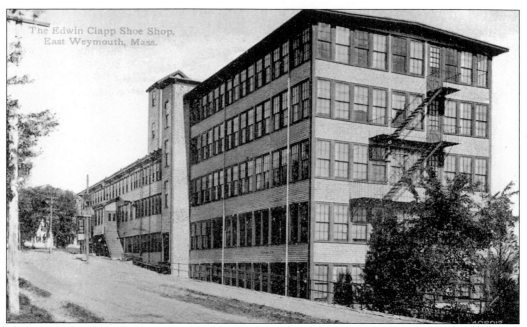

The Edwin Clapp Shoe Shop, East Weymouth, Mass.

This was the third of the Edwin Clapp shoe factories and was located on Charles Street. The site is currently occupied by an apartment building. Shoes manufactured here found a worldwide market and were noted for their high quality. The three successive Clapp factories manufactured shoes for about 100 years, from the time of the Civil War until the 1960s.

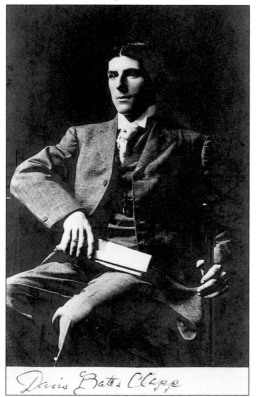

Davis Bates Clapp

Davis Bates Clapp, the son of Edwin Clapp, died on September 5, 1901. He was only 23 years old. In 1903, his parents erected the Davis Bates Clapp Memorial Building to provide "means for physical exercise and social recreation" for young men and women. This photographic postcard is prepared in the undivided-back style, indicating that photographic postcards have been with us from the beginning of the postcard era.

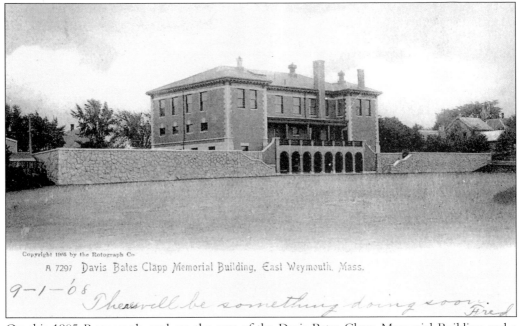

A 7297 Davis Bates Clapp Memorial Building, East Weymouth, Mass.

9-1-'08 There will be something doing soon. Fred

On this 1905 Rotograph card are the rear of the Davis Bates Clapp Memorial Building and a portion of its six-acre playing field. The building and its adjoining field served its stated purposes for over 50 years. Today, the building serves as a church. A portion of the six-acre field is occupied by senior housing.

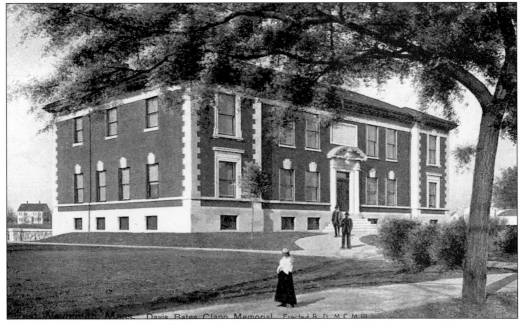

Weymouth, Mass. Davis Bates Clapp Memorial Erected A.D. M C M III

The Clapp Memorial, as it is affectionately known, is located on Middle Street, East Weymouth, in the heart of the Central Square Historic District. This full-photo-era postcard gives us a front view of the 1903 building as it appeared early in the 20th century. Today, as it serves the community as a church, its appearance is relatively unchanged.

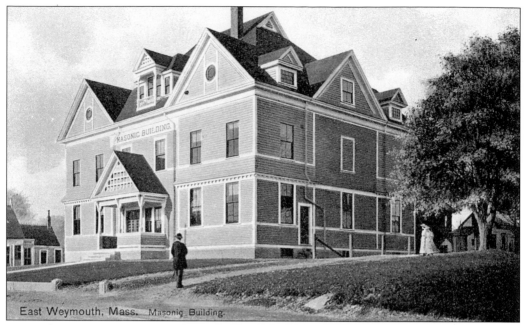

East Weymouth, Mass. Masonic Building.

Fraternal organizations were popular in the last half of the 19th century and in the first half of the 20th century. On this postcard is the wood-frame Masonic building on Broad Street, west of Jackson Square. It was dedicated in October 1884 and served 27 years before being destroyed by fire in January 1912. The postcard is from the full-photo era (1907 to 1920).

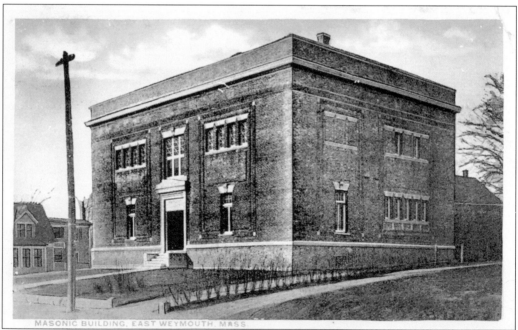

MASONIC BUILDING, EAST WEYMOUTH, MASS.

As a result of the destruction by fire of the 1884 Masonic building, another was erected in its place and dedicated in 1914. It is in the Central Square Historic District. For 90 years, this replacement building has helped Weymouth's Masonic groups to provide for their various charitable activities. The card shown here is from the white-border era (1915 to 1930).

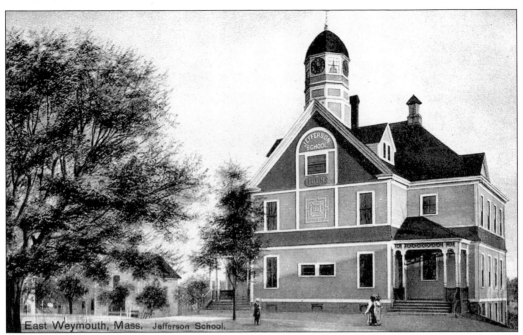

The Jefferson School, constructed in 1889, still serves the community as the South Shore Day Care. It is located on Middle Street, across from the Clapp Memorial, in the Central Square Historic District. Painted white for many years, it has been repainted to match the colors shown on this postcard.

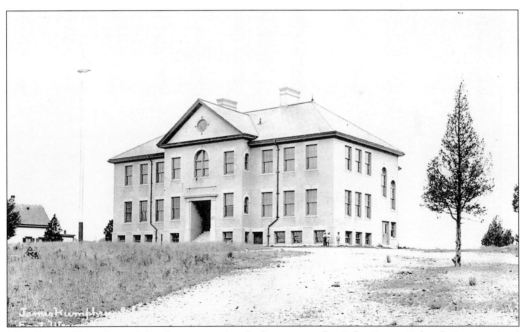

The James Humphrey School was previously known as the Lake Street School. It contained eight classrooms. A large addition was added in the 1950s. Like so many other of the old schools in town, it has been converted to condominiums. Judge James Humphrey was prominent in 19th-century Weymouth education.

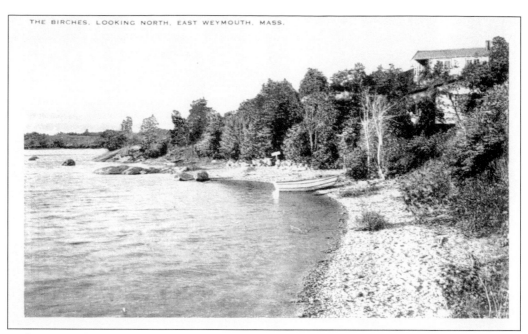

In the 1920s, the section of town known as the Birches was developed. It was close to Whitman's Pond and consisted of mostly summer cottages—some on the pond and some overlooking the pond. Today, most of the cottages have been converted to year-round residences.

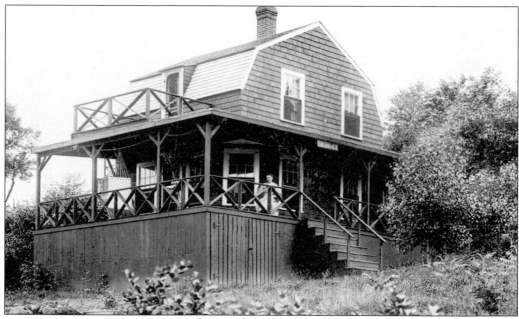

Just as some vacationers visited the saltwater beaches of Weymouth, other vacationers enjoyed the freshwater ponds of the town. The sign over the stairway proudly proclaims, "The Birches." Proximity to the pond, recreational facilities, and business establishments on nearby Washington Street (Route 53) made the Birches a desirable place to vacation.

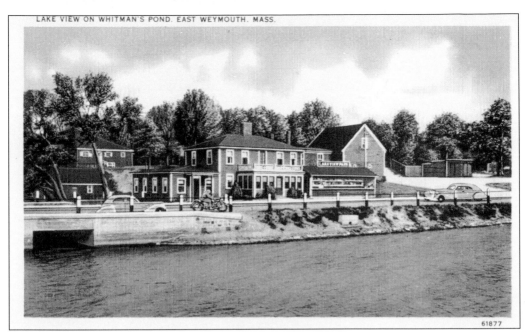

This linen-era (1930–1944) postcard shows Lake View Park, 948 Washington Street. The former owner, a Mr. Mace, maintained a hotel, a dance hall, and other amusements here. The complex was situated on both Whitman's Pond and Route 53, which was the old (c. 1810) Braintree and Weymouth Turnpike. It provided recreational activities for vacationers in the Birches.

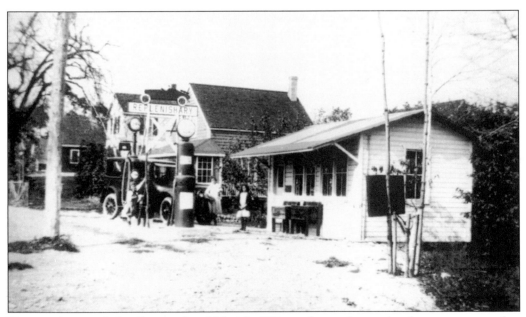

You may be awarded a Congressional Medal of Honor for service rendered to our country, but after that you still have to earn money on which to live. William Seach, who earned the honor in the Boxer Rebellion in 1900, earned a portion of his living operating this "replenishery," or gas station, at 978 Washington Street (Route 53), between Lake View Park and the Birches.

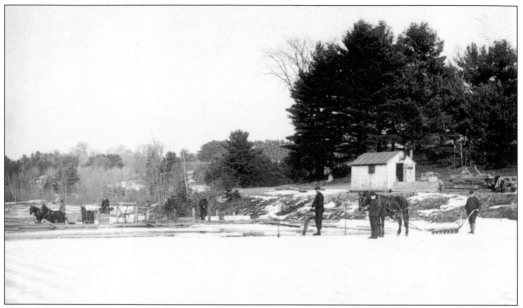

Until the 1940s, when household refrigerators became commonplace, the ice harvest was an important part of the annual cycle. Here we see ice harvesting on Whitman's Pond. Horse teams and wagons are in the water being loaded with ice. A worker is sawing blocks of ice by hand. Two workers and a horse are making preliminary cuts in the ice. This scene is off shore from Mr. Mace's property.

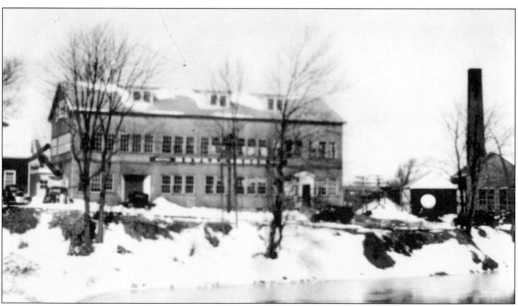

Situated between Whitman's Pond, Middle Street, and Route 53 was the Howe and French chemical plant, manufacturers of lacquers, solvents, thinners, and shellacs. Mill River enters Whitman's Pond from this site. A strip mall anchored by a Shaw's supermarket now occupies the site. The river is now channeled underground through the mall site.

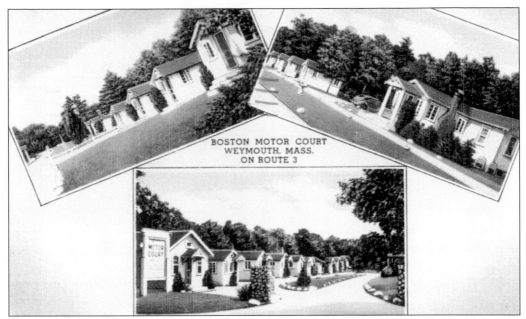

Boston Motor Court, on Route 3 (now Route 53) in East Weymouth, was "one of New England's finest stopping places at the Gateway to quaint, historic, Old Cape Cod!" Here we see it in an advertising card postmarked 1951.

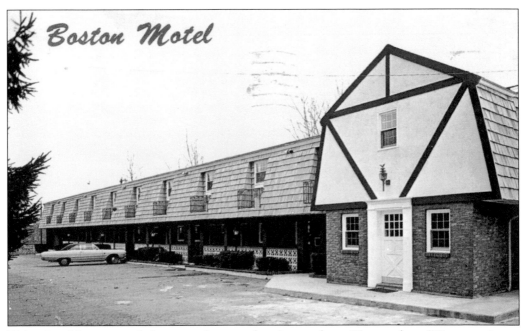

This advertising postcard shows us the same location as above 20 years later. "Twenty minutes from Historic Boston and Quaint Old Cape Cod," the wooden cabins above are replaced with "new modern units with color TV, phones, air conditioning, individually controlled heat." The property is now a part of the Super 8 Motel chain. The card is postmarked 1975.

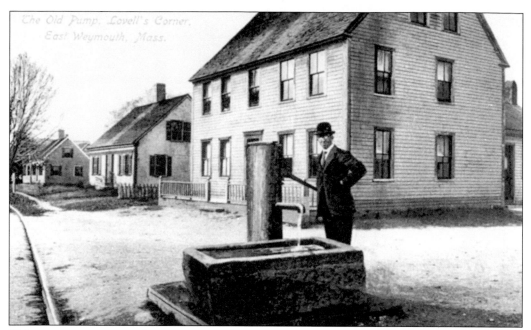

This water pump served generations of townspeople at Lovell's Corner, the intersection of Washington Street (Route 53) and Mutton Lane. The pump and the large house behind it are gone now, but the two Cape-style homes to the left are still used as residences. Notice the omnipresent trolley tracks.

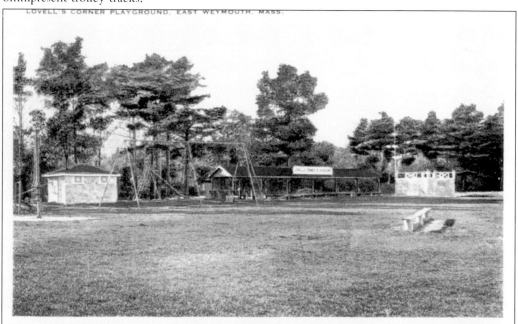

About a quarter-mile south of Lovell's Corner is Lovell's Corner Playground. The playground, now known as Bradford Hawes Playground, is on Lakehurst Avenue, near its intersection with Mutton Lane. Bradford Hawes was a prominent school committeeperson and selectman in late-19th- and early-20th-century Weymouth. He donated this land to the town. The card is from the white-border era.

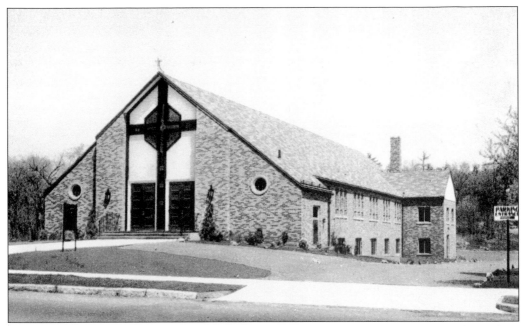

The Church of St. Albert the Great, the newest of Weymouth's Catholic parishes, is located on Washington Street, near Lovell's Corner. The parish was established in 1950. The church, designed in a contemporary gothic style, was dedicated in 1954. The George H. Hunt Company published this glossy-style postcard in the 1950s.

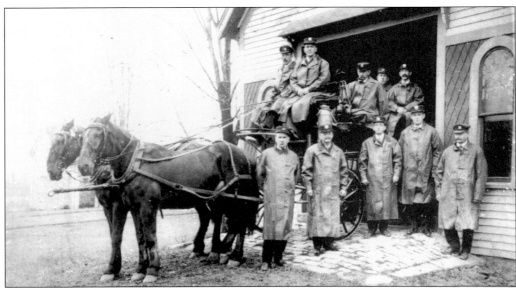

A hose company of Weymouth's fire department poses for a photograph in front of Station No. 7 at Lovell's Corner in East Weymouth. This hose company participated in firemen's musters at the Weymouth Fair Grounds and other locations. The company was disbanded in 1919, and the building has gone through various uses since then. Today, the neighboring auto body repair shop occupies the building.

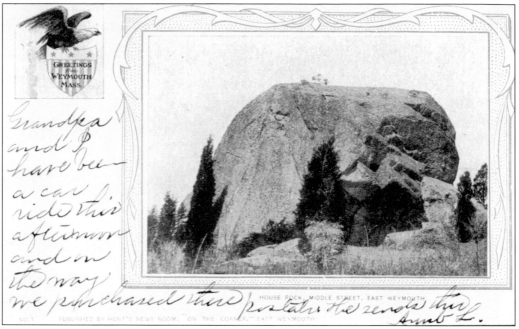

GREETINGS
from
WEYMOUTH
MASS.

Grandpa and I have been a car ride this afternoon and on the way we purchased this postals. She sends this. Aunt L.

HOUSE ROCK, MIDDLE STREET, EAST WEYMOUTH
NO. 1 PUBLISHED BY HUNT'S NEWS ROOM, "ON THE CORNER," EAST WEYMOUTH

Receding glaciers deposited this 3,500-ton boulder, known as House Rock, over 10,000 years ago. It is the largest boulder in New England. The rock is located in House Rock Park, off House Rock Road, off Essex Street. The postcard is postmarked 1905. Early explorers of Weymouth mentioned House Rock in their historical writings as early as the 1620s.

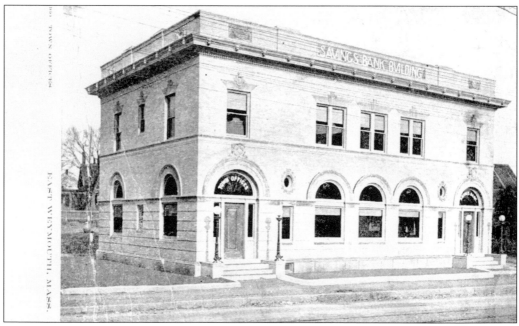

In 1901, due to overcrowding at the 1852 town hall, which was still situated on its original site, additional office space was rented on the second floor of the East Weymouth Savings Bank building. Offices were maintained there until a new town hall was constructed in 1928. Notice the lettering above the left door of the bank building.

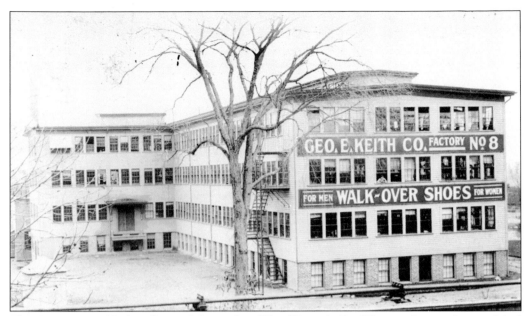

The George E. Keith shoe factory is located on Wharf Street in East Weymouth, near the municipal transfer station. It is still used for industrial purposes, but shoes are no longer manufactured there. When shipping by boat was prevalent, Wharf Street was the land access to the wharves that serviced marine interests in the Weymouth Back River. This card is postmarked 1919.

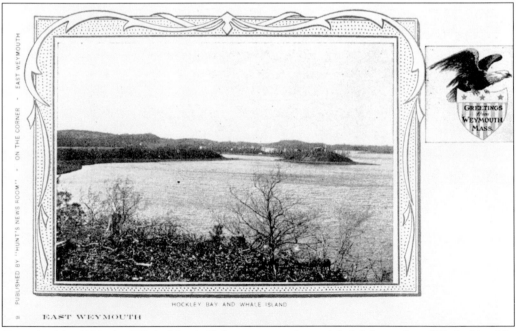

Organized in 1901, the Whale Island Club was a popular social club located on Whale Island in the Back River in East Weymouth. Like the other owners of land abutting the Back River, the Whale Island Club lost its island *c.* 1910, when the government took the Back River area for military defense. The club relocated to the Fore River area.

A Kiss from Everybody in East Weymouth, Mass.

Leaving this part of town, a lovely lady sends us off with "a Kiss from Everybody in East Weymouth." Generic postcards such as this are still popular in tourist sites. The cards have a scene available to every vendor, and then the cards are overprinted with an identification of the vendor's community. The card dates from *c.* 1915.

Five

SOUTH WEYMOUTH

This watercolor of the John Reed House shows Columbian Square before the Fogg Building (the bank's second location) was erected on this site.

Columbian Square is the economic and social center of South Weymouth. Seen here is its rural setting in the 1870s. Fogg buildings occupy three of the four corners of the square. The Fogg building referred to on this card is the Fogg Opera House, built in 1888. The town's first library, a privately owned one, was on this site *c.* 1800. Notice the community water pump in the center and the steeple of Union Congregational Church on the skyline.

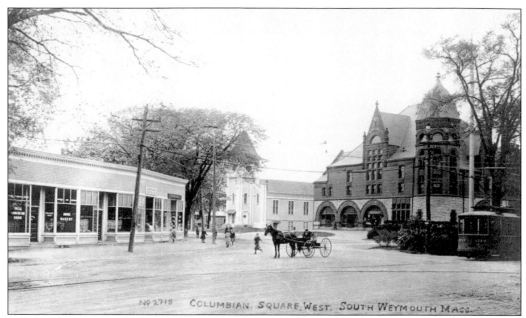

Seen is Columbian Square *c.* 1900. The commercial block on the left is still actively used. The leftmost shop, the Ideal Luncheon Room, offers "college ices" in one window and "home bakery" in another window. The Second Universalist Church stands next to the Fogg Opera House. A horse-drawn wagon seems to pose in the center of the square while a trolley enters the scene from the right.

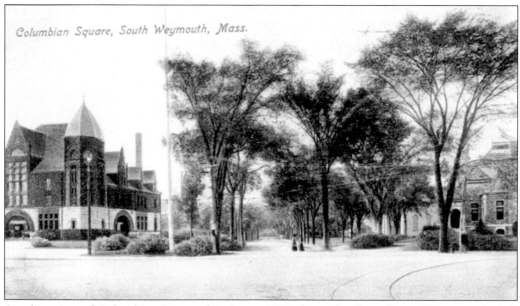

Another view of Columbian Square, this time *c.* 1920, shows the Fogg Opera House on the left, Weymouth's elegant elm trees in the center, and the Fogg Library on the right. The chimney at the rear of the Fogg Opera House is part of that same building. The flagpole to the left of center is standing on Bayley's Green, where the militia drilled in Revolutionary War times.

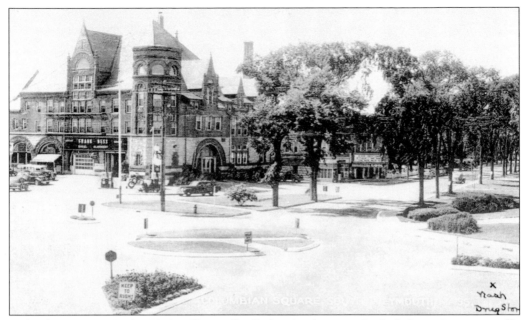

Columbian Square in the 1940s still proudly displays its elm trees. Bayley's Green is now a traffic island. The conical roof on the Fogg Opera House has been removed. The new theater's marquee, to the right of center, can be seen through the trees. Farther down Columbian Street, obscured by the elms, are the Union Congregational Church and the South Shore Hospital.

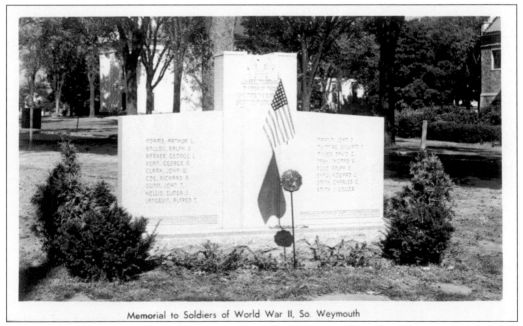

Memorial to Soldiers of World War II, So. Weymouth

Weymouth has sent her men and women to serve their country since the town was first founded. This memorial to the men of South Weymouth who lost their lives in World War II stands on the grounds of the Fogg Library. Here, local residents remember the sacrifice made by these young men. Listed on the memorial are the names of 17 men.

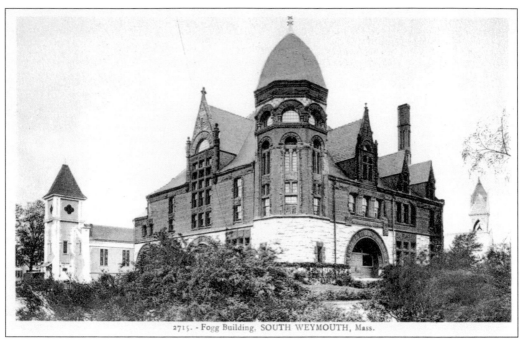

2715. - Fogg Building, SOUTH WEYMOUTH, Mass.

A majestic view of the Fogg Opera House is the main feature of this postcard. To the left of the opera house is the Second Universalist Church that burned in 1954. To the right is Union Congregational Church that merged with Old South Church in 1918 and was razed *c.* 1960. The magnificent Fogg Opera House was built in 1888.

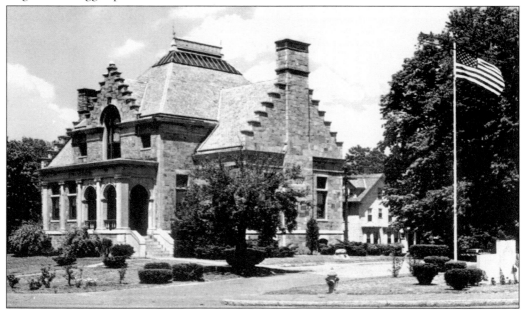

John S. Fogg (1817–1892) was a prominent shoe manufacturer and philanthropist in Weymouth. Today, three of the four corners that constitute Columbian Square are dominated by Fogg buildings. The Fogg Library, shown above, was financed by a legacy from the will of John Fogg. It was made of Weymouth seam-face granite and was dedicated in 1898. It is now part of Weymouth's public library system.

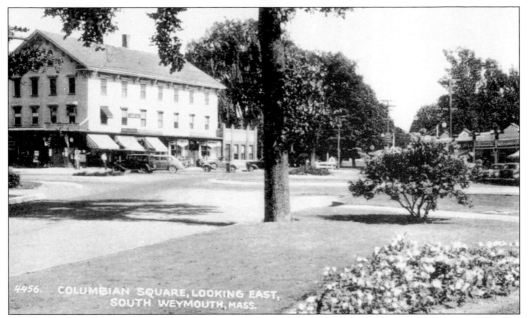

The former Fogg shoe factory was constructed *c.* 1857. It included the town's first elevator. This postcard shows the factory as it appeared it the 1950s and as it appears today. Shoe manufacturing was a primary occupation of the town in the latter half of the 19th century and the first half of the 20th century. Weymouth at one time had over 75 shoe manufacturers in town. None remain.

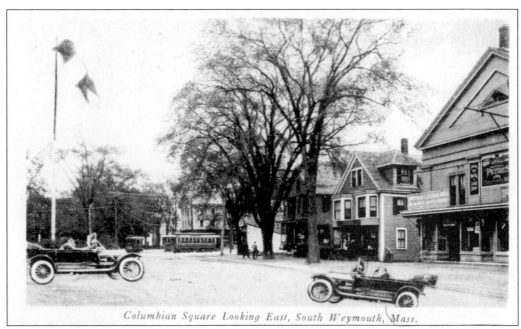

Columbian Square Looking East, South Weymouth, Mass.

This interesting early-19th-century postcard of Columbian Square looks east on Pleasant Street. The Fogg shoe factory stands behind a trolley. The retail outlet for Magee Ranges and Heaters was built in 1843 as the first Union Congregational Church. The building also houses a local motion picture theater. The Chauncy building now stands on the site. We hope the passengers in the "flying automobiles" are enjoying their ride.

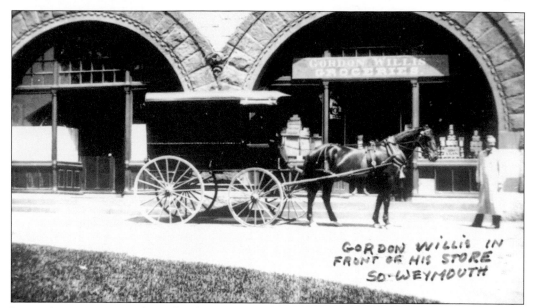

Just as it was common for a family to pose before its home with prized possessions, business proprietors did the same. Here, Gordon Willis poses in front of his store with his prized delivery wagon. The store is located in the Fogg Opera House. The small neighborhood store, which was prevalent before the era of the supermarket, does not appear often on postcards.

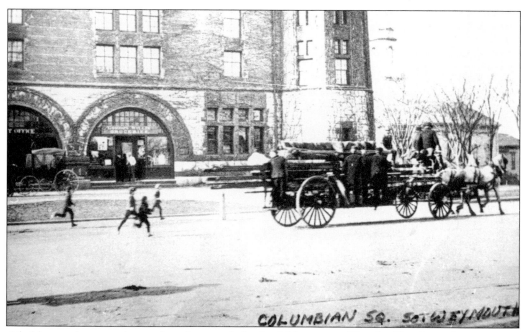

A ladder truck responds to a fire alarm early in the 20th century. The familiar Fogg Opera House with the post office and Willis's grocery store forms the backdrop. Youngsters pursue the fire truck east on Pleasant Street. The church in the background is Old South Church. Weymouth received its first motorized fire truck in 1913 and three more in 1914.

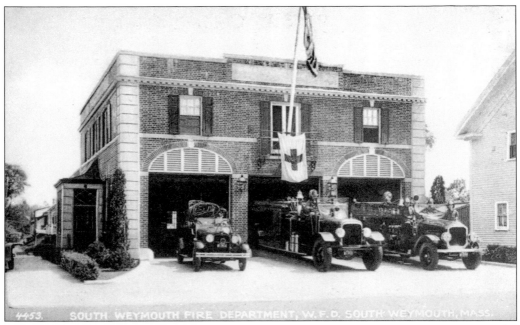

The Red Cross flag hanging from the firehouse indicates that first aid can be obtained here. The flag also reminds us that firefighters do more than fight fires. The time is the early 1940s, and the nation is actively involved in World War II. The well-maintained fire trucks are ready to respond to any emergency.

This view is of the same firehouse a decade or so later. The fire trucks have responded to countless calls and have been replaced with more modern vehicles. In the same tradition as every fire department, the trucks are ready for a quick response. This firehouse is now closed and sold to a private party. A new firehouse on Park Avenue protects the community.

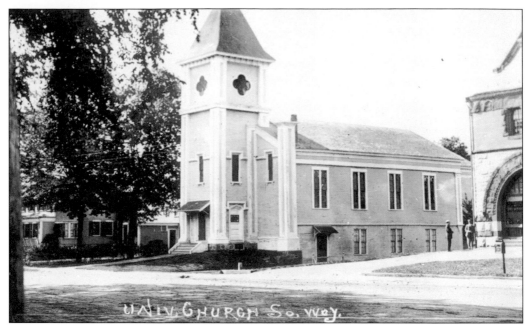

The Second Universalist Church traces its history back to 1835. The members of the church organized *c.* 1849 as the Washington Corporation, which met in various nearby locations until building a chapel in 1850. Throughout the 1850s, improvements were made to the original building. The improvements included the addition of a steeple. In 1858, the members reorganized as the Second Universalist Society of Weymouth. The church burned in 1954.

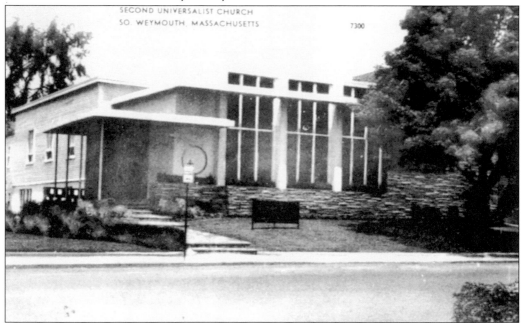

Due to the fire in 1954, the Second Universalist Society rebuilt its church in a more modern style. It serves today as a commercial building housing a function hall and shoe-repair business. Many of the members of this church joined the Third Universalist Church in North Weymouth (see page 54).

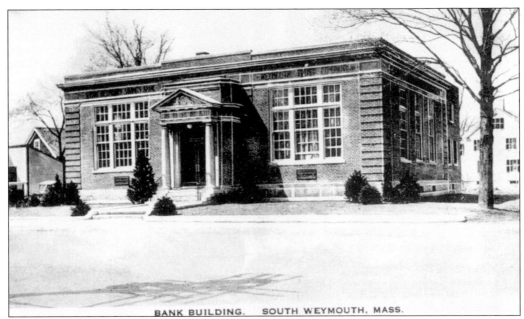

BANK BUILDING. SOUTH WEYMOUTH, MASS.

South of the Second Universalist Church is the South Weymouth Savings Bank. At one time, it was the main office of the bank. The bank has merged with other banks, is headquartered farther south in town, and is now known as the South Shore Savings Bank. The building continues to serve the community as a branch of that bank. The card is from the white-border era (1915–1930).

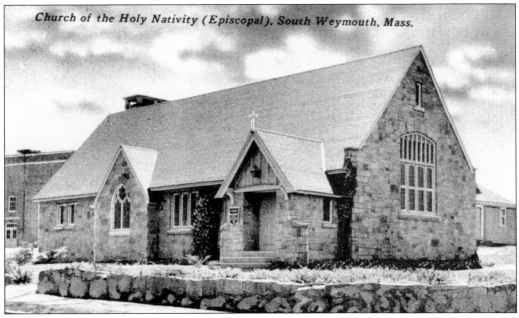

Church of the Holy Nativity (Episcopal), South Weymouth, Mass.

The Episcopal Church of the Holy Nativity is located west of the Edwin B. Nevin School (see page 103). The church was founded in 1915, and ground was broken for the building in 1919. Construction of major additions started in 1958. Today, the church continues to serve the need of its members. The Edwin B. Nevin School is in the left background.

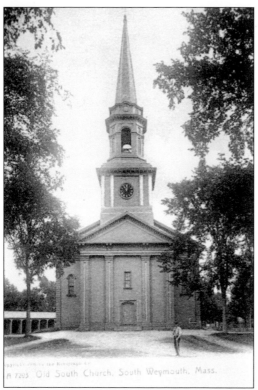

A 7205 Old South Church, South Weymouth, Mass.

This house of worship of Old South Church was built *c.* 1855. Due to a maintenance accident, the church burned to the ground in 1988. Because the building was listed on the National Register of Historic Places, the external appearance of the structure had to remain the same. However, significant improvements were made to the interior of the building.

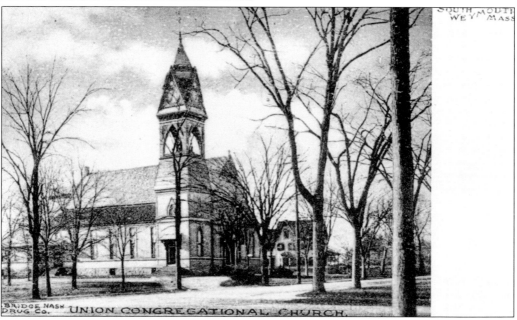

UNION CONGREGATIONAL CHURCH.

Just west of Columbian Square, at the corner of Fogg Road and Columbian Street, is the site of Union Congregational Church. The edifice seen above was dedicated in 1872. The congregation merged with Old South Church in 1918, forming Old South Union Church. The building was used as a parish house and ultimately torn down in the 1960s for use as a hospital and church parking lot.

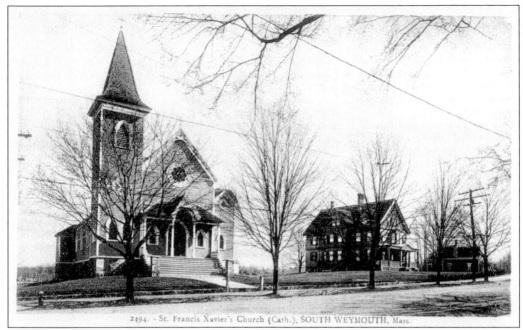

2494. - St. Francis Xavier's Church (Cath.), SOUTH WEYMOUTH, Mass.

The second St. Francis Xavier Church, built *c.* 1869, and the parish house were located on Pleasant Street. The church was taken down in the 1960s, and the site is used for parishioner parking. The former parish house still stands. The photograph used for the postcard was taken *c.* 1910. Note the lack of buildings in the background.

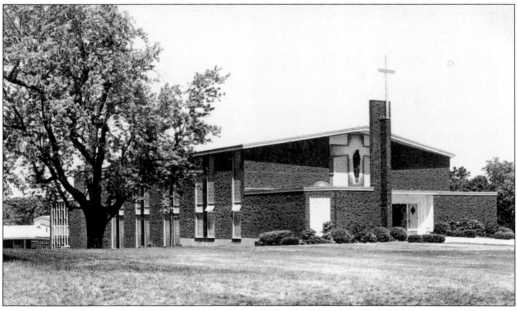

Cardinal Cushing dedicated the third St. Francis Xavier Church in 1959. It is located across the street from the wood-frame church shown above. The new church includes an elementary school, a sanctuary, and a parish office. The St. Francis Xavier parish is the oldest of the five Catholic parishes in the town.

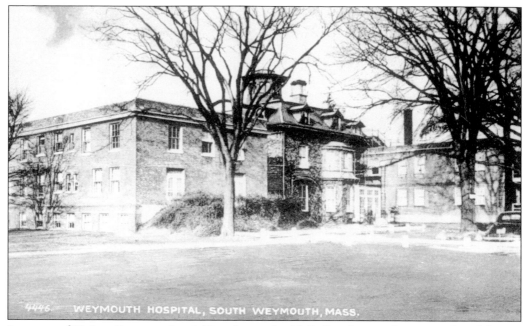

Just west of Union Congregational Church was the H. B. Reed estate. It was purchased for use as the Weymouth Hospital for the townspeople. Seen here is the Reed mansion with its first two hospital wings attached. The hospital's name has changed, the Reed mansion is gone, and a labyrinthian structure, serving the entire South Shore, stands on the site.

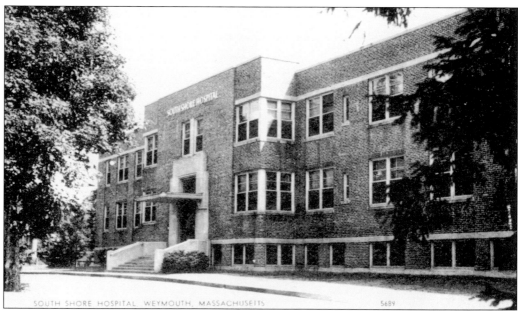

By the 1950s, the Weymouth Hospital had become the South Shore Hospital. The hospital is located on the block formed by Fogg Road, Main Street, and Columbian Street. The former main door of the building, illustrated above, was located on Columbian Street. Since the 1950s, the hospital has grown significantly, adding several wings and additional land.

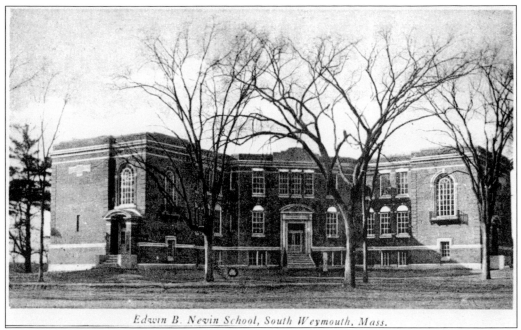

Edwin B. Nevin School, South Weymouth, Mass.

Across Main Street from today's hospital is the Nevin building, a condominium of medical offices. It is built on the site of the former Edwin B. Nevin School, which is pictured here. Edwin B. Nevin was a political leader in Weymouth. The 10-room school was erected in 1917 and, like so many other older schools at the time, was sold to a private party *c.* 1980.

Traveling north on Main Street (Route 18), halfway down the hill on the right is the hospital's outpatient facility. It is the site of the former South Weymouth Custom Laundry. The laundry has been razed, and today the site is home to a modern medical facility. Route 18 is the old New Bedford Turnpike, originally constructed *c.* 1805. N. E. Williams of Columbian Square published the card.

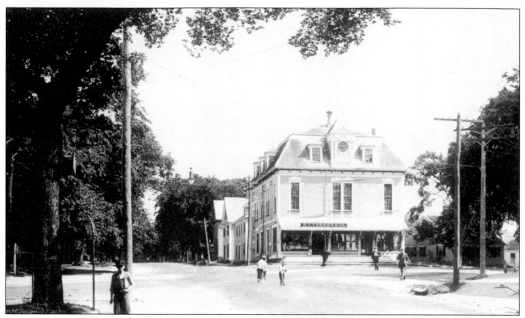

Independence Square is south of the hospital and at the intersection of Pleasant, Pond, and Main Streets. Wildey Lodge's Odd Fellows Hall, built *c.* 1882, dominates the square in the scene above. W. F. Turner & Company occupies a retail outlet in the building. A horse-watering trough blends into the building. A strip mall, anchored by a Marshall's department store, now occupies the corner to the right.

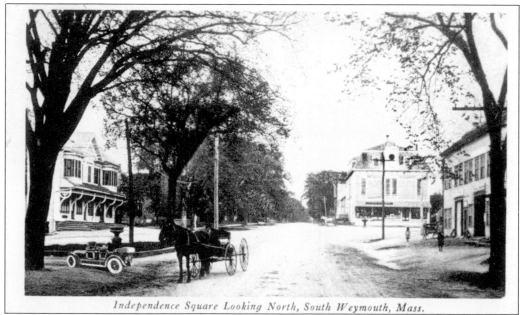

Independence Square Looking North, South Weymouth, Mass.

In another view of Independence Square, we see a broader panorama. The house to the left is gone. In the 1950s, a then modern, up-to-date supermarket occupied the site. Now a Walgreen's occupies that former supermarket. The building on the right is also gone. Two horse-watering troughs and a horse-drawn wagon complete the original picture. An automobile has been superimposed on the picture to make it appear more modern.

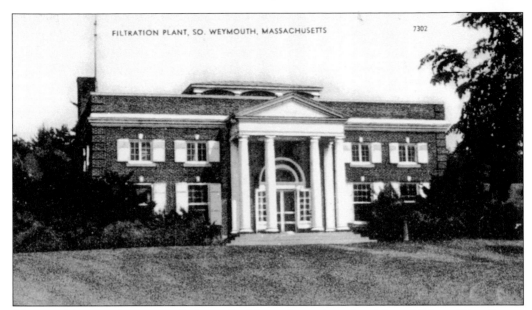

Weymouth's water department is charged with continuously maintaining a high quality of water for the town residents. This filtration plant is one of the facilities that the water department uses for this purpose. Weymouth residents receive their water from the Great Pond in South Weymouth and five wells scattered around town. The facility, now with additions, is located off Pond Street in South Weymouth.

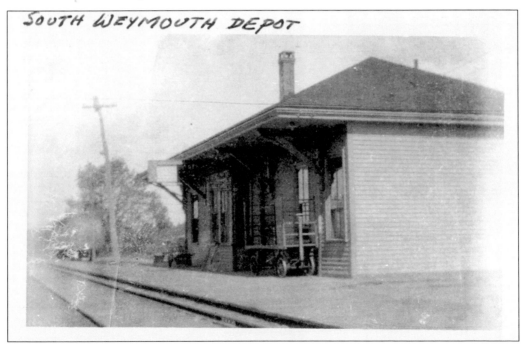

This photographic postcard shows the South Weymouth railroad depot as it appeared *c.* 1915. The Old Colony line serviced this train station until the 1950s. In 1997, rail service resumed on this line, but the new depot was located farther south. A private party is planning to restore the depot as an office.

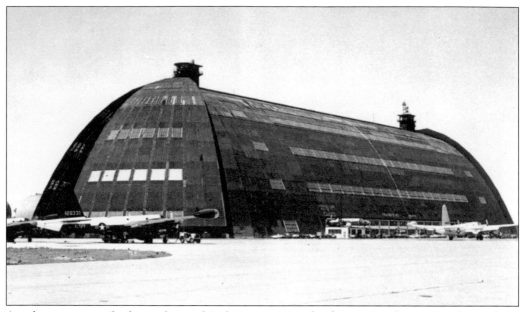

Another quarter-mile down the road is the entrance to the former South Weymouth Naval Air Station, in operation from 1942 to 1997. During World War II, its blimps helped defend the North Atlantic from enemy submarines. The huge blimp hangar, which covered eight acres, was built in 1942 and was taken down *c.* 1970.

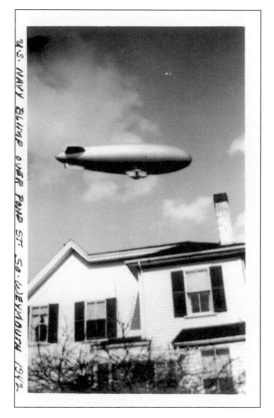

This photographic postcard shows a blimp flying over a South Weymouth home. Such sights were familiar to Weymouth residents during and after World War II. Navy blimps over South Weymouth became a thing of the past in 1961, when the last blimp squadron was disestablished.

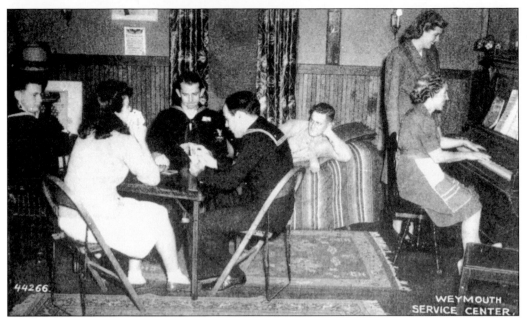

About a half-mile from the former main gate to the air base was the Weymouth Service Center. Here, the personnel from the base were able to relax away from the rigidity of military life. Postcards, such as the one illustrated, were available to send home. Today, the building is owned by the Patriot Trail Girl Scout Council and serves the needs of Girl Scouts.

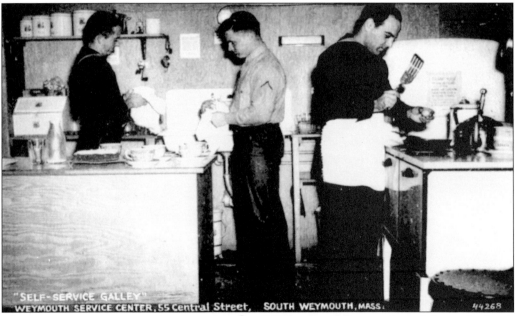

Three servicemen are preparing a meal in the Self Service Galley on Central Street in South Weymouth. Notice the glass milk bottle on the table and the mechanical can opener on the wall. It was inevitable that, with the influx of military personnel to the town, marriages between military and local population would occur. Many of the couples stayed in town.

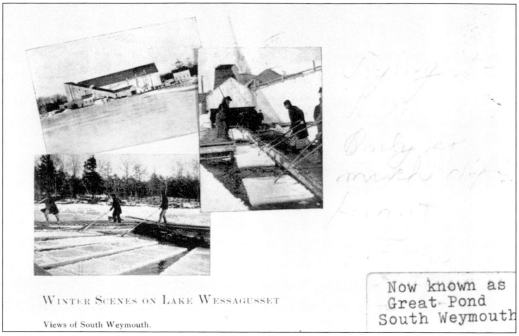

Now known as
Great Pond
South Weymouth

WINTER SCENES ON LAKE WESSAGUSSET

Views of South Weymouth.

Triplets (three pictures on the face of a card) were popular with the 1901–1907 undivided-back postcard. This 1905-postmarked card shows two ice-harvesting scenes and an icehouse for storage. Enough ice was harvested to supply the retail ice sellers from one season to the next. South Pond and Lake Wessagusset are two former names for Weymouth Great Pond.

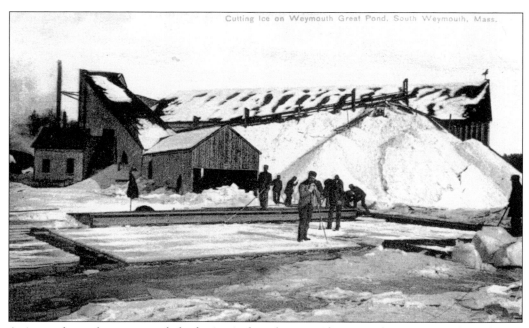

As it travels up the conveyor belt, the ice is shaved to a uniform size for storage in the icehouse. The mounds of waste ice that obstruct the view of the building are the results of this shaving. These mounds of ice would not melt until late summer.

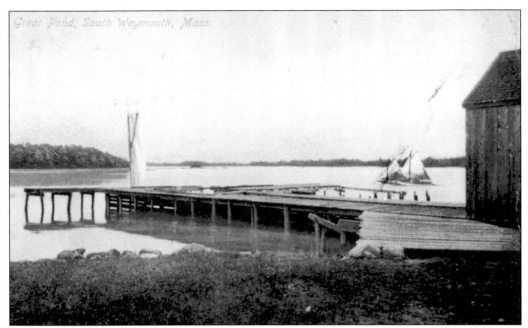

This is a summer view of one of the several icehouses that were on Weymouth Great Pond's shores. Notice the private sailboats. In order to improve the quality of the town's water supply, the town prohibited recreational and commercial use of the pond *c.* 1925. The land surrounding the pond was purchased and is now a protected watershed.

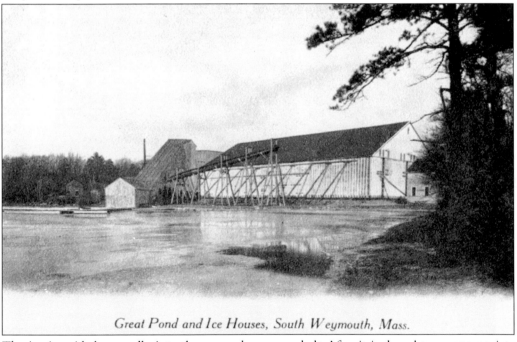

Great Pond and Ice Houses, South Weymouth, Mass.

The ice is guided manually into the covered conveyor belt. After it is shaved to an appropriate shape and size, the ice is guided to storage inside one of the icehouses on Weymouth Great Pond. Each layer of ice is separated from the next by sawdust, hay, sand, or other suitable material. The exposed conveyor belt carries off shavings.

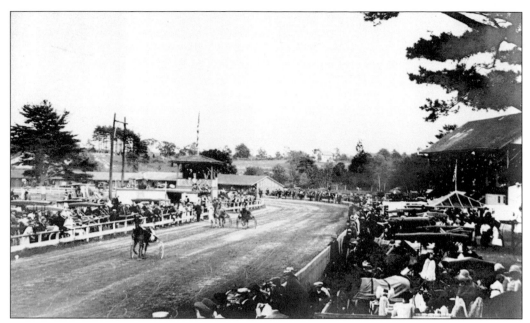

The Weymouth Fair provided entertainment and education for more than 100 years. Agricultural exhibits, 4-H activities, cooking competitions, horse racing, and a midway all contributed to the success of the fair. Changing times and changing interests caused a severe decline in the popularity of local fairs in the 1960s. In this postcard is a general view of the popular trotting races. The card is postmarked 1912.

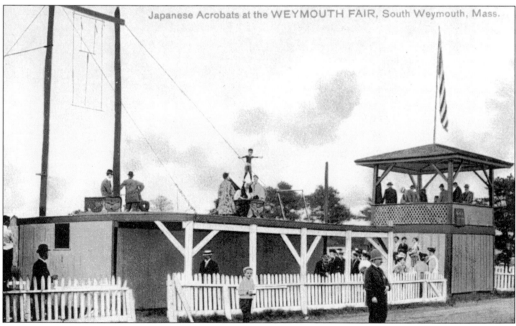

Japanese acrobats perform in this c. 1907 Weymouth Fair. The adjacent viewing stand overlooks the raceway. Notice the policeman's uniform hat. A victim of changing times, the Weymouth Fair was held for the last time in 1972. This Hunt's postcard is of the full-photo era (1907 to 1920).

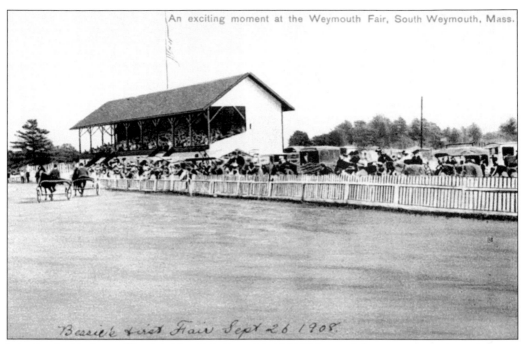

An exciting moment at the Weymouth Fair, South Weymouth, Mass.

Bessie's first Fair Sept 26 1908

Join the family fun at "Bessie's First Fair, Sept. 26, 1908." The card shows two trotters as they pass the grandstand. A mix of horses, people, and automobiles watch at the railings. The card is an example of the full-photo-era cards. It carries the familiar lettering "Published by Geo. H. Hunt & Co., The Post Card Store."

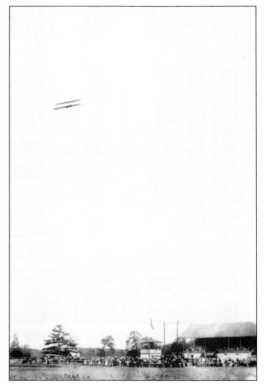

Fairgoers get a preview of things to come as they watch a biplane perform at the 1910 Weymouth Fair. It has only been seven years since the first heavier-than-air flight. Starting in 1954 and continuing through 1996, the U.S. Navy provided air shows at the naval air station. A crowd at the railing, the Japanese acrobats' stanchions, and the racing view stand are visible in the background.

111

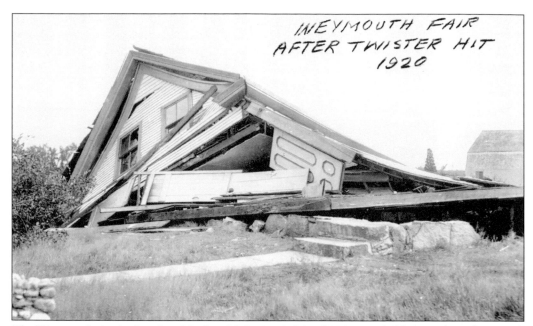

The Weymouth Agricultural and Industrial Society's fair of 1920 was held three days after South Weymouth, including the fairgrounds, was visited by a tornado. The date of the tornado was August 31, 1920. Postcards were prepared to tell distant friends and relatives of the damage that was done.

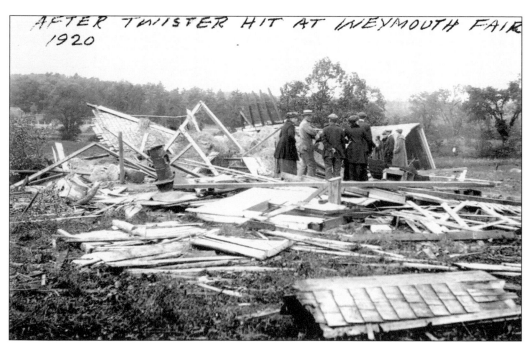

At the fairgrounds, the cattle barns sustained the most damage. Nevertheless, the show did go on. Off the fairgrounds, the town and its citizens responded by forming committees to help their neighbors who had suffered damage and to raise money to pay the expense of rebuilding. The fairground was the scene of a field day for this fund-raising purpose.

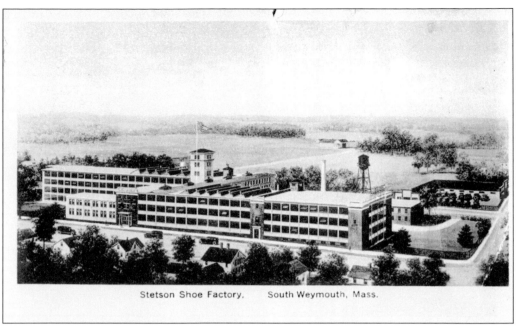

Stetson Shoe Factory, South Weymouth, Mass.

An architect's rendering of the Stetson shoe factory at the corner of West and Main Streets found its way to this postcard. After its career as a shoe factory ended, the building was totally renovated for office use but maintained its external appearance. Because of its proximity to the South Shore Hospital, many of the offices in Stetson Place, the building's new name, are medical offices.

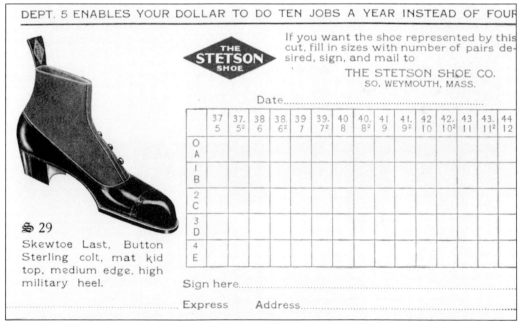

DEPT. 5 ENABLES YOUR DOLLAR TO DO TEN JOBS A YEAR INSTEAD OF FOUR

THE STETSON SHOE

If you want the shoe represented by this cut, fill in sizes with number of pairs desired, sign, and mail to

THE STETSON SHOE CO.
SO. WEYMOUTH, MASS.

Date................

		37 5	37. 5²	38 6	38. 6²	39 7	39. 7²	40 8	40. 8²	41 9	41. 9²	42 10	42. 10²	43 11	43. 11²	44 12
O	A															
1	B															
2	C															
3	D															
4	E															

$ 29

Skewtoe Last. Button Sterling colt, mat kid top, medium edge, high military heel.

Sign here...............

............ Express Address...............

Postcards are ubiquitous. Here, a postcard previously attached to sales literature makes wholesale ordering more convenient. The lack of a postal zone, the precursor to zip codes, hints that the postcard was printed before 1943. The Stetson Shoe Company was the last of more than 75 Weymouth shoe factories to close. Stetson manufactured shoes from 1885 to 1973.

When Route 128 was a meandering two-lane highway (with bumper-to-bumper traffic) it passed through South Weymouth and by Tom Curtis's Greenview Farm, now the site of Dorothy's Dry Cleaning. Greenview Farm offered "Wife Savers: Fresh Roasted Chicken, stuffed and ready to eat. Home Made Beef Stew. Chickens and Turkey Roasted on Order. Party Orders Solicited." This advertising card dates from *c.* 1945.

The Pond Plain Improvement Association was organized in 1908. From its inception, its purpose has been to improve the quality of life in the Pond Plain section of South Weymouth. The association constructed this meeting hall on Pond Street in 1923. The organization and its meeting hall still serve their original function.

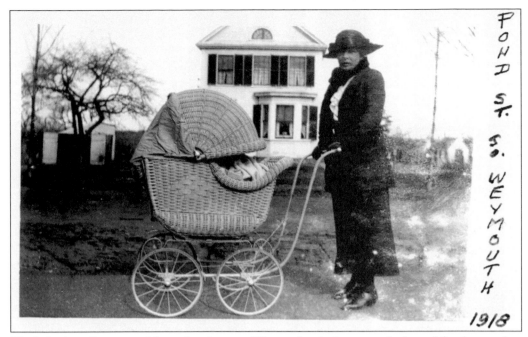

The baby is well protected from the elements. The mother is also properly dressed for the weather. Her shoes are designed for walking. The baby carriage has large wheels to ease its passage over the bumps of the walking route. This is a photographic postcard.

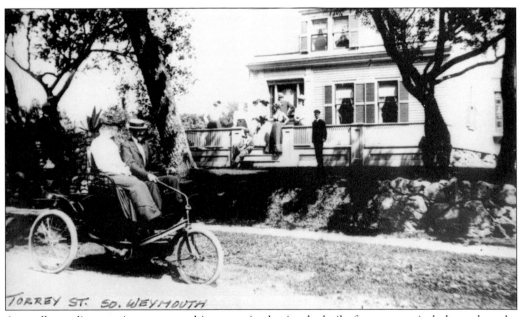

A small gasoline engine powers this motorized tricycle built for two as it helps usher the automobile age into Weymouth. A house party in the background is in progress. The year is *c.* 1915, and the location is Torrey Street in South Weymouth. The card is a photographic postcard.

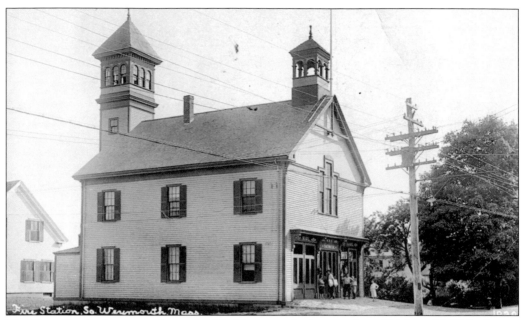

The Hose Five firehouse was located at Nash's corner, the intersection of Main and Middle Streets. In the 1880s, it housed the *General Putnam,* a horse-drawn hand pumper. The *General Putnam* participated in fire musters of the era, some of which were held at the Weymouth Fair Grounds. It won some contests and set some records. The pumper was sold to Worcester in 1891.

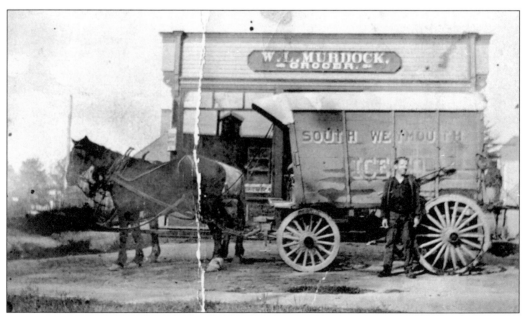

Delivery service was commonplace in the first half of the 20th century. As late as the 1940s, it was common to see local businessmen making deliveries, some still with a horse and wagon. Green grocers, bakers, milk trucks, scissors and knife sharpeners, junk collectors, ice trucks, and others were common sights on Weymouth streets. Seen here is W. L. Murdock with his ice-delivery truck.

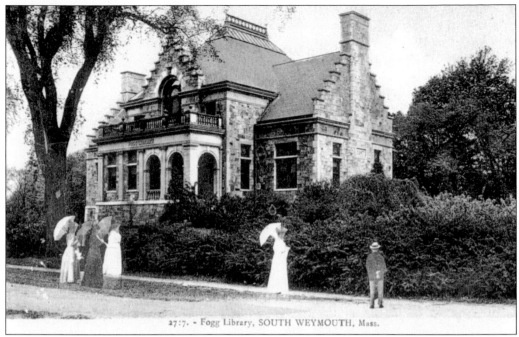

27:7. - Fogg Library, SOUTH WEYMOUTH, Mass.

Ghostlike figures patrol the sidewalk outside the Fogg Library in South Weymouth. This white-bordered card is from an era noted for taking shortcuts to save production costs. Here, the printers have taken an old photograph of the library, reused it, and added disproportionately sized people to the card in order to modernize the scene.

BAND CONCERTS in Columbian Square were a common sight for many generatio yesteryear. The cars in this old photograph indicate the picture was taken aroun World War I era.

This photographic postcard bears a striking resemblance to the one on the bottom of page 18. The cars are parked in a similar fashion, and they appear occupied by drivers and passengers. Perhaps, to cap off the day, a parade of these new automotive devices is planned. The location is Columbian Square.

117

A class picture is printed on a postcard, making it easier to share with distant relatives. This is the seventh- or eighth-grade class of the Bates School, located on Central Street in South Weymouth, *c.* 1913. The teacher, Everett Hollis, is not seen. The students are, from left to right, as follows: (front row) Harold McRea, Guilford Churchill, John W. Field, John Leary, Francis Daly Marr, Daniel Madden, and John Dondero; (middle row) Charles Descaizo, Evelyn Ford, Margery Davis, Florence Chase, Agnes Welch, Ethel Church, Catherine Mielby, and Alice Daley; (back row) Leona Doble, Elsie Ford, Bertha Sangolier, Jessie O'Linnie, Esther Thompson, Ruth Dunn, Olive Ralph, Annie Healy, and Edward Kiernan.

Six

POTPOURRI

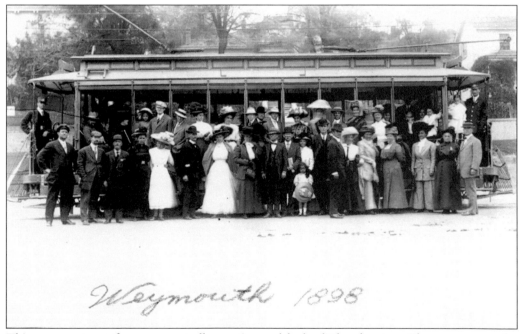

Weymouth 1898

This group set out for an open trolley outing and had a little adventure. The message on the card reads, "We all came down to Nantasket via Hingham for our outing. Trolley got stuck en route but was free after being towed by a team a spell." The card dates from *c.* 1908, 10 years after the event.

Weymouth's popular tree warden, V. Leslie Hebert, published this card *c.* 1960. The legend on the card reads, "Sons of Liberty assembled under Liberty Tree, Boston, Mass. A symbol of freedom from Aug. 14, 1765 to Aug. 1775 when it was cut down by British Soldiers because it bore the name of Liberty."

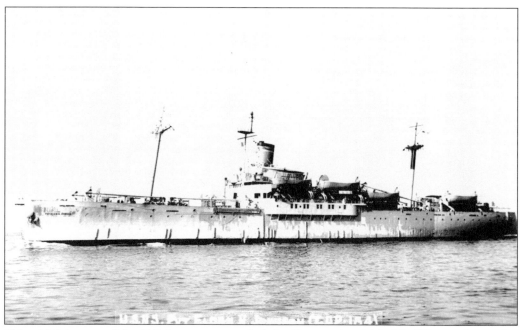

Elden H. Johnson, of the U.S. Army, was awarded the Congressional Medal of Honor for service in Italy. Johnson, a Weymouth man, earned the honor in 1944 "for conspicuous gallantry and intrepidity at risk of life above and beyond the call of duty." In 1947, the *Pvt. Elden H. Johnson,* a hospital ship, was named in his honor. Johnson is one of five Weymouth men who have earned the Congressional Medal of Honor.

Happiness is a Healthy Mouth

A Weymouth dentist sent this postcard to remind children that it was time for their dental examinations. Doctors, dentists, and others use postcards to remind clients of professional appointments. Some of their cards are quite clever. Some are quite boring but reflect the times. This dentist probably never used a computer-generated postcard or mailing list. This card is postmarked 1979.

Dear ~~Friend,~~ *Bill & Elaine*,

Dick Ramponi is running for re-election to the **Weymouth Board of Selectman.**

Dick has been an accessible, responsible hard-working selectman over the past three years.

Dick has a strong record of accomplishment and would like to continue to serve the people of Weymouth. He needs our help to do that. Please cast one of your two votes to

Re-Elect **Richard E. "Dick" Ramponi**
Your Weymouth Selectman on Election Day,
Monday, May 20, 1985.

Sincerely,

Joe & Millie LoPresti

The open face of a postcard allows the recipient to read the message without having to open an envelope. Postcards are inexpensive to print and inexpensive to mail. Politicians use advertising postcards to get their message across quickly and minimize their postage expenses. This political postcard has a picture of the politician on the address side.

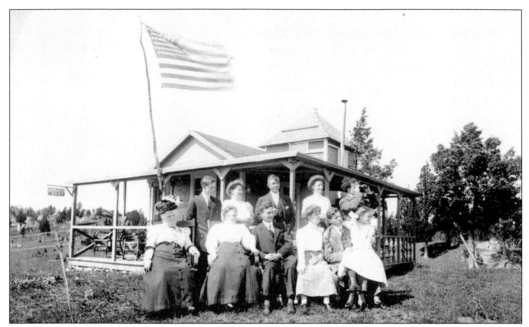

Summer visitors of three generations pose before their North Weymouth cottage. The sign on the left corner of the building reads, "Knockers Rest." A homemade flagpole proudly waves a 45-star flag (1896–1907). The gentleman at the right end of the back row is peering through binoculars.

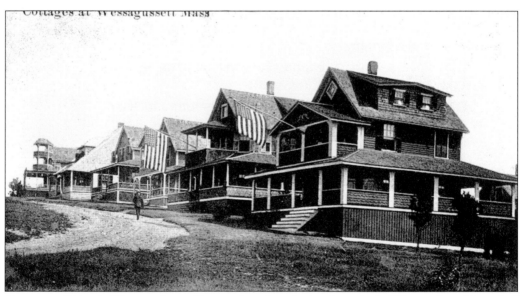

Cottages of North Weymouth are illustrated on hundreds of postcards. What makes this typical view of Wessagusset cottages somewhat more interesting is the clear display of the short-lived 46-star flag (1907–1911). Facts, such as the number of stars on the flag, caught by the camera help collectors date their postcards.

Some generic postcards are more elaborate than others. This one has a message handwritten with glue and sprinkled with a glittery substance. The miniature envelope attached occasionally contained a slip of paper on which a message could be written. "Post Card" is printed in 17 different languages on the back. The card is a 1907 issue.

Booker T. Washington was a noted educator at the start of the 20th century. Like thousands of his contemporaries, he found Weymouth a nice place to have a summer home. The house illustrated on this photographic postcard was Washington's summer home in 1902 and 1903. Washington was one of the major speakers in Weymouth's 1903 Old Home Week. The house was diagonally across the street from the hospital.

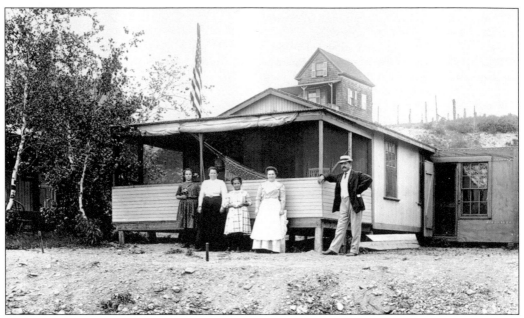

A family poses in front of its summer cottage in North Weymouth. In the days before photography became ubiquitous, a family often would pose in front of their home with their prized possessions. In this case, the only prized possessions visible are the dolls that each of the younger girls are holding and the cottage itself. Notice the horseshoe stakes in the foreground.

Family portraits on a season's greetings card are not a new idea. This 1907 postcard sends a photograph of the family to friends and relatives on the season's greeting card list. The message reads, "I guess you know all these. Nat is sick. Ruggles alongside of Charlie." Apparently, the card was enclosed in an envelope because there is no postmark on it.

Vera Freeman was an art teacher in the Weymouth schools in the 1940s. She and a fellow artist, Marion Ray, tried their hand at selling some of their original works by having an exhibit at Freeman's barn. They prepared a block-print advertisement and stamped it on several U.S. post office 1¢ postal cards. The postmark on this postal is 1940.

During the summer of 1920, at the request of town residents, a motorcycle officer was added to the police department to enforce the traffic rules and to reduce speeding incidents. In this photographic postcard is Officer Hutchinson ready to patrol on motorcycle WPD No. 1. Motorcycle officers are still an important part of traffic safety enforcement.

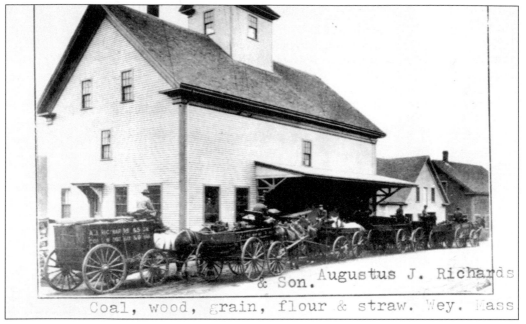

Coal, wood, grain, flour & straw. Wey. Mass
& Son. Augustus J. Richards

Augustus J. Richards was an East Weymouth businessman who sold coal, wood, hay, and grain and promised prompt delivery. He was also prominent in town affairs, having served many years on the school committee and as selectman. He conducted business from the 1880s to 1912. Here, his fleet of delivery wagons is waiting to go.

Naval heroes from two different wars meet. Congressional Medal of Honor holder William B. Seach meets John F. Kennedy. Seach earned the medal during the Boxer Rebellion in China in 1900. At the time, Seach was an ordinary seaman with the U.S. Navy. Although Kennedy was not a Congressional Medal of Honor holder, he is noted for his heroic behavior in the Pacific during World War II.

W1UIR SO. WEYMOUTH, MASS.

18 IVY ROAD

2 - 6 - 10 - 15 - 75 METERS

RADIO _W1 G L_

UR QSO ON _3960_ MC

UR SIGS QSA _5 - 20/9_

DATE _3 - 7 - 57_

MEET ME ON THE AIR

PSE QSL - TNX - 73

VIKING 2
75A2 / HQ129 X
Dip Antenna

'ROLIE'

GEORGE ROLAND CHAMBERLAIN

A common hobby in Weymouth is amateur radio communications, popularly known as ham radio. When ham radio operators communicate with one another, locally or internationally, they often exchange QSL cards, or acknowledgments, so that they have written confirmation of their successful contact. The cards identify the time, date, wavelength, and station call letters. Some QSL cards are elaborately illustrated; others are relatively plain.

KOA-4896 The Old Fisherman

WARREN & MARGARET
CHRISTIE

60 PURITAN RD.
WEYMOUTH, MASS. 02188

Monitor 13

ALL 23 & MOBILE

The above QSL card is from a CB radio operator. Like their counterparts, ham radio operators, CB radio hobbyists exchange QSL cards to acknowledge successful communications. Shortwave radio listeners can also request QSL cards from broadcasters. CB operators, ham radio operators, and shortwave radio enthusiasts often make collections of their QSL cards. QSL cards illustrate another popular use of the postcard.

OLD HOME WEEK.

Weymouth extends a hearty invitation to all her sons and daughters, far and near, to take part in her observance of Old Home Week, commencing July 29, 1906.

For the Committee and in behalf of the Town.

JOHN J. LOUD, Chairman.

MARTIN E. HAWES, Secretary.

A celebration, provided for by vote of the town, will be held at the Fair Grounds, South Weymouth, on Saturday, August 4th, commencing with a Parade at eleven o'clock followed by a basket collation, ball game, athletic contests and band concert. An apportunity will be given to listen to short addresses from former residents of the town.

An effort is being made to have a union religious service in each village on Sunday, August 5th.

At the end of July and the beginning of August 1906, the town celebrated its second Old Home Week. Each village of the town was scheduled for a portion of the celebration. The activities included public speeches, baseball games, band concerts, a river parade of powerboats, a banquet at the Fogg Opera House, church services, and a parade. Public transportation was hindered because the crowds were unusually large.

OLD HOME WEEK

POSTAL CARD

WEYMOUTH, MASS.

WELCOME HOME.

EVENTS

AUG. 26-27 Band Concerts.

AUG. 27 or 28 Banquet at Foggs Opera House.

AUG. 29 Stereopticon. Town Hall

AUG. 30 River Illumination. Weymouth and North Weymouth.

AUG. 31 Ball Game at Clapp Memorial Grounds, and other attractions.

SEPT. 1 Church Services.

LOUIS A. COOK, Chairman.
 FRANK A. BLANCHARD, Secretary.

We hope you have enjoyed this 20th-century postcard tour of historic Weymouth. Let us take this opportunity, through the medium of a 1912 postcard invitation, to invite you to participate in an Old Home Week celebration of your own by visiting Weymouth again, either in person or through a repeat tour of this book.